ALBERTA

prairie to peaks

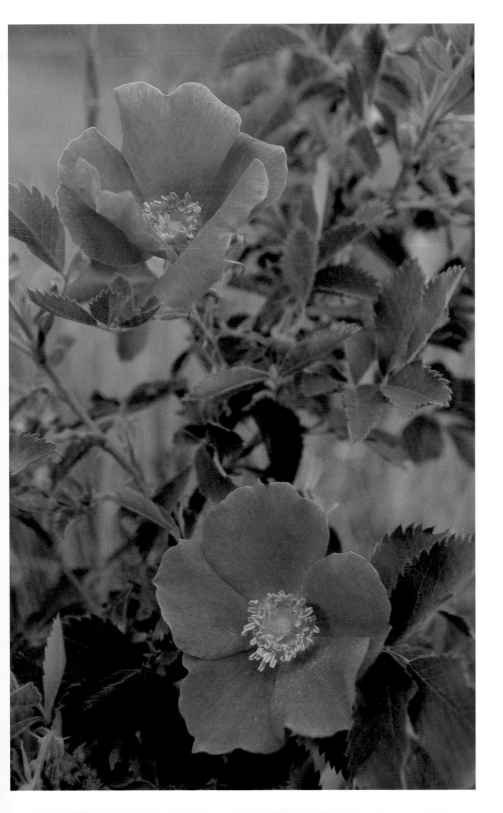

ALBERTA

prairie to peaks

Photography and text by Ron Richardson

Here and There Publishing
Wynyard, Saskatchewan

The Prickly Rose, floral emblem of Alberta, is widespread and common throughout the northern prairies and forests of North America and Russia. It grows in open forest and clearings, along river banks, and around sloughs. Native Americans used many parts of the rose bush for medicinal purposes as well as for food. The roots were used to treat snow blindness and other eye problems, and to make a tea to treat coughs. Both rose hips and flowers can be used in teas and jellies, even wines. Rose water and rose oil are used in perfumes and skin washes.

Here and There Publishing
P.O. Box 1597
Wynyard, Saskatchewan
Canada, S0A 4T0

All photographs, including cover, by Ron Richardson.
Book and cover design by Ron and Libby Richardson.

First Edition

Printed and bound in Canada

National Library of Canada Cataloguing in Publication

Richardson, Ron, 1943 -
 -- ALBERTA : prairie to peaks / Ron Richardson.

ISBN 0-9680420-2-3

 1. Richardson, Ron, 1943-. 2. Alberta--Pictorial works.
3. Landscape photography--Alberta. 4. Nature photography-
-Alberta. I. Title.

FC3667.4.R53 2004 779'.367123'092 C2004-901505-2

The Publisher gratefully acknowledges the Government of Saskatchewan, through the Cultural Industries Development Fund, for its financial support.

For more information:

Internet at: http://www.hereandtherephotos.com
E-mail to: book@hereandtherephotos.com
Telephone: (306) 554-3811

Also available from the same author and publisher
....it's just PRAIRIE - Ron Richardson - ISBN 0-9680420-0-7
....it's just PRAIRIE TOO- Ron Richardson -ISBN 0-9680420-1-5

Bulk purchase discounts are available for sales promotions, corporate gifts, premiums, fundraising and seminars. For more information contact Here and There Publishing.

 All images in this book are considered to be "Foundview Images". Nothing has been added to or subtracted from the original image, produced by a single exposure only, and no image has been altered in any way that would cause the viewer to feel that he or she had been deceived.

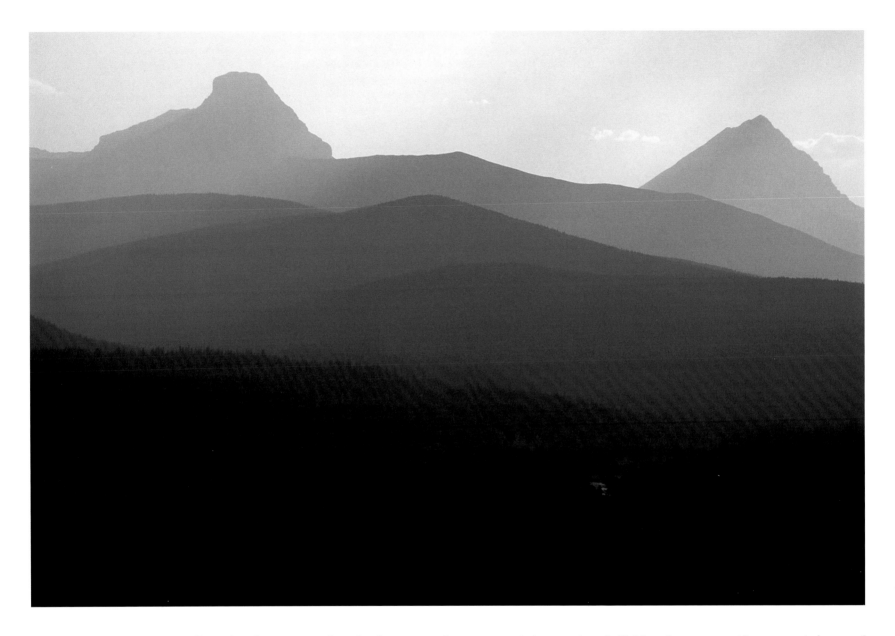

Huge forest fires in the mountains during one of my many trips cast a dull blue haze over the mountains and valleys of the Kananaskis Country. I love the illusion of depth in the photo created by the many hills and the progressive blurring of detail as the eye follows over each ridge to the next, until it reaches the distant peaks. Depth is harder to achieve in a simple photograph like this because there is nothing in the image that the eye can use for comparison of scale.

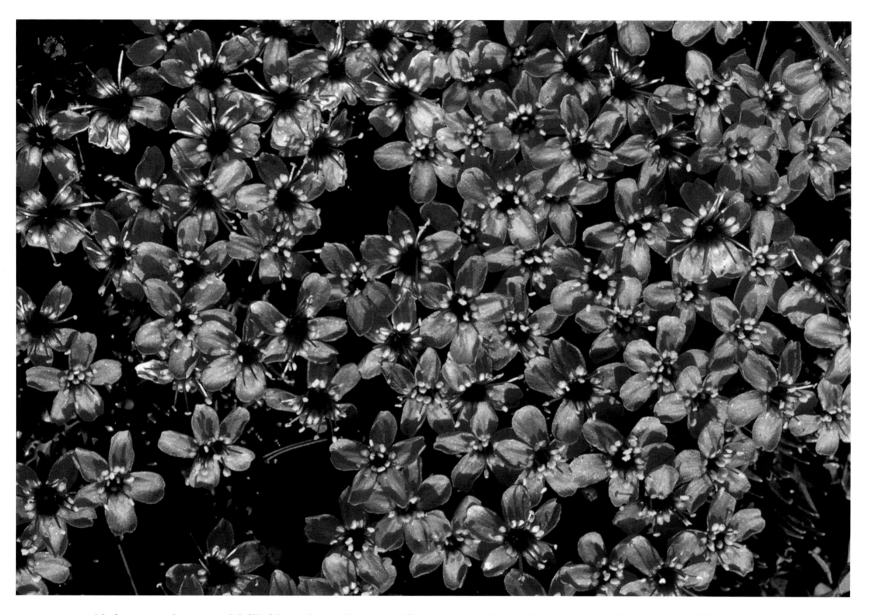

Alpine meadows and hillsides above the tree line are a palate of colour in midsummer. The snow recedes and many tiny plants rush to complete their cycle of growth before the snow flies again, covering them for another year. This is Moss Pink, or Moss Campion, which grows in clumps up to half a metre in diameter but only a few centimetres high, as protection against frigid, drying winds. It grows in rock crevices and other moist areas above the tree line, with flowers only 6 mm. in diameter. This photo was taken on Parker Ridge near the Columbia Ice Fields.

TO THE PEOPLE OF ALBERTA

For your help in so many ways

during the many trips and thousands of kilometres of travel

to capture the many thousands of images needed to produce this book.

Acknowledgments

Thank you to so many people for your assistance and guidance in the preparation and production of this book.

Thank you first and most importantly to all the people in Alberta who assisted me in so many ways with suggestions, information, directions and friendship. I have enjoyed meeting many new and interesting friends and acquaintances.

Thank you to all the people who opened their homes to me for a night or two, and sometimes longer. My sister Linda and Terry in Calgary, Mick and Brenda and family in Edmonton, and Alan and Arla and family in Stony Plain, among others. Thank you also to my mother, Alta; Libby's mother, Norma; and my father and his wife, Russ and Vera; for the many times you have provided "Bed and Breakfast" for Libby and me.

A very special thank you to Alan High for all your help, advice, direction and information over the past few years; and especially thank you for your friendship. I have very much enjoyed the many photo shoots we have done together and look forward to many more.

Thank you to Tim and Jean Wickenheiser for the time you spent finding out who the cowboy was.

Thank you again to my favourite proof readers, Wendy and Lillian.

A very big thank you to my wife, Libby, for all your support and help during times of need and your patience during times of stress. I can always rely on your objective viewpoint when I am too close to the subject to make an unbiased judgement.

And finally, thank you to all my customers, family and friends who have supported and encouraged me over the years, especially in the preparation and production of "....it's just PRAIRIE" , "....it's just PRAIRIE TOO", and now "ALBERTA – prairie to peaks".

This is one of the very few photographs in the book that were taken many years ago. Friends were visiting from New Zealand and I took them to the Columbia Ice Fields during their stay. At that time the tongue of the Athabasca Glacier was much further down the valley than it is now and part of the glacier ended with a sharp vertical face. Out of a large cave at the bottom of this ice cliff ran the main meltwater stream. It was a bit dicey getting into the cave as there was a constant rain of ice bits and rock debris falling from the top of the glacier, but once inside the surroundings were spectacular. This photo, looking towards the entrance, gives only a hint of the beautiful blue colouring of the magnificently water-sculpted sides and roof of the cave.

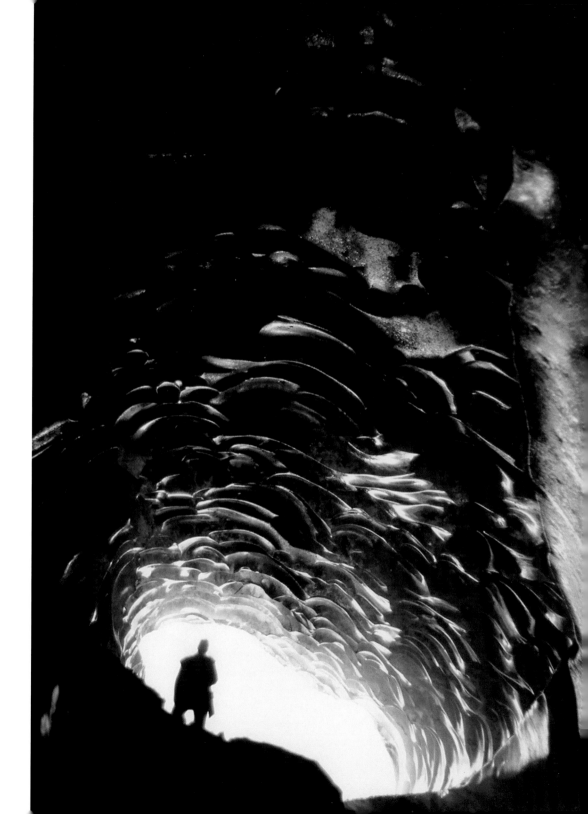

Introduction

Alberta has a varied landscape spread over an area of 661,188 sq. km. Elevations range between 200 m. above sea level, at the lowest point on the plains, and 3,747 m. at the peak of Mt. Columbia, the highest point in Alberta. Typical landforms in the province include flat prairie, rolling hills, alpine slopes, canyons, mountain peaks, and glaciers. Vegetation on these landforms includes everything from grassland, forest and muskeg, to alpine meadows and rocky outcrops. As you would expect, the diverse terrain brings about a varied climate, from summer heat on the prairies to perpetual cold on the high peaks. The major rivers in the province begin in the snow and ice of the Rockies, and flow either into the Arctic Ocean, or into Hudson Bay and the Atlantic Ocean. The Milk River, along the southern border of the province, flows into the Missouri River and eventually into the Gulf of Mexico.

Settlement by European farmers and ranchers began in the late 1800's, mostly British, but many immigrants of other nationalities as well. The province still has a lot of farm and ranch land, but is now also one of the most energy-rich provinces.

Alberta is a land of natural spaces; vast forests, pristine lakes, wide prairies, and the magnificent Rocky Mountains. Although there are many spectacular mountain views and beautiful places that are easily accessible, there are still large tracts of wilderness where humans are almost insignificant; wild places, reached only on foot, where human impact has been minimal. If at all possible, visit in the "off season", when there are fewer buses, fewer tourists, and many more places to be explored in quiet solitude.

Over the last four years I have made many trips around Alberta, each lasting between 5 and 15 days. Each of these journeys has taken me at least 4,000 km., over 100,000 km. in total, including travel to each of the four borders of the province several times. These excursions have been in all seasons of the year and in all weather conditions.

During most of my travels around Alberta I more or less lived out of my truck. I find it much easier to be where I need to be, when I should be, if I'm already there. To get an early morning shot, for instance, I would park somewhere nearby – in a campground or at a rest stop – sleep in the back of the truck, and not have to drive any great distance in the morning. A mattress and sleeping bag were all I needed. This didn't always work in my best interest. On one occasion, along a deserted mountain road, a bear came to visit in the middle of the night. He wasn't easily discouraged, even when I pounded on the side of the truck with my boot. He finally left but returned twice more before morning.

Unlike my first two books, which covered the prairie only, this book tries to capture the character of the whole province of Alberta, including the majestic mountains along the western border. This required a little more effort on my part, as I don't find it as easy to capture good mountain images as I do good prairie images. There are so many books on the market with great mountain photography in them that I felt anything I did in the Rockies had to be special and unique. I feel that I have achieved my goal. I hope you agree.

The production of this book has been a lot more work and has required significantly more travel than " it's just PRAIRIE " or " it's just PRAIRIE TOO ". As with those books, however, the work has been a labour of love, and very satisfying.

During my travels I took over 10,000 photographs, selecting about 400 of them for possible use in the book. From those 400, with help from friends and relatives, I chose the final 136 transparencies. All of the photos in the book are considered "foundview" images, which means: 1) Nothing has been added to or subtracted from the image after the shutter was released and 2) Nothing has been done to alter the image, either before or after the shutter was released, that would make the viewer feel that he or she had been deceived.

I believe that the best time for most photography is early morning or late afternoon. The light is better for most landscapes, the wildlife is generally active, and it's just a nicer time of day to be out. Because there are only a few of those hours each day, and no one can guarantee suitable conditions at **any** time, a particular photo often requires a return trip – or two, or three! In fact, no matter how many times one returns to a specific location or wildlife area, something will always be different. You won't always get the photograph you were looking for, but isn't the attempt half the fun?

Finally, I would like to say a few words about the wilderness that I love. Nature is fragile! We have become accustomed to having so many conveniences in our everyday lives that we don't stop to realize what the cost of these little extras is to the environment. Did you know that approximately 90% of the world's resources are used by only 10% of the world's population? We need to take better care of our planet. We can not continue to ask more of Mother Nature than she is able to give. We are already being affected directly (consider smog alerts and UV warnings), but our children and our grandchildren will feel much greater repercussions.

My hope is that this book will become an information source; an incentive for you to get out, find your own memories and become more aware of your environment. Please, have fun and enjoy!

Given the history of oil in Alberta, it seemed appropriate to include a photo of one of the many oil derricks that are drilling in the province at any one time. This is a "service rig" which is brought in after the initial drilling is done by the larger "drill rig". The service rig completes the preparation of the hole and installs the pipe so that the pumpjack can be put in place over the well and the oil can be pumped to the surface.

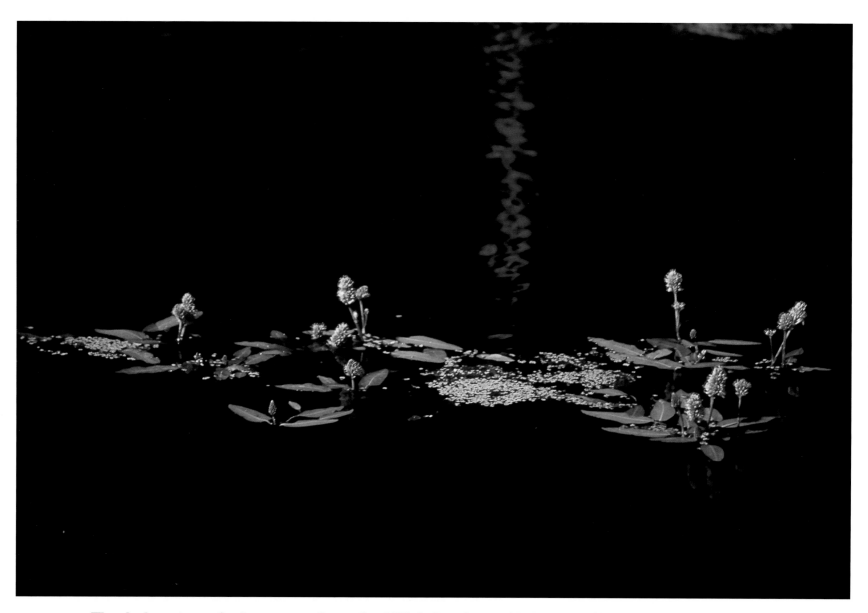

The dark waters of a beaver pond, north of High Level, provided a beautifully contrasting background for the green leaves and bright pink flowers of the Water Smartweed. This plant is widespread throughout the parkland and boreal forest areas of North America. The root was used by some of the native peoples as a cure for blisters in the mouth, and the plant was sometimes used to treat various complaints of the human hindquarters. In fact, smartweed was once known as "arsmart" due to the irritation of "that area" caused by the leaves.

ALBERTA

prairie to peaks

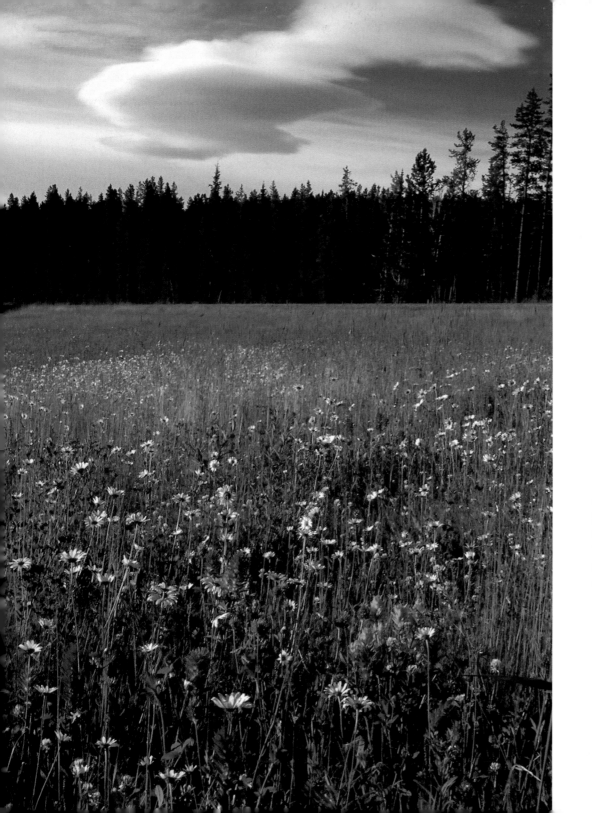

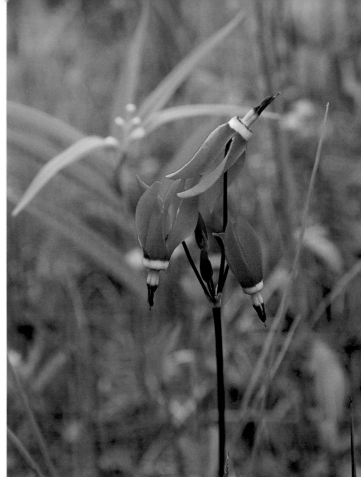

▲ ▶ I've never before seen such a huge patch of virgin prairie covered with shooting stars. The dandelions are common enough, but the large number of shooting stars was amazing. What a gorgeous site! What a great feeling to stand in the midst of it all!

◀ A beautiful patch of wildflowers in a ditch in northern Alberta is set off by an odd cloud formation in the sky above. Flowers seem to thrive better and are more varied and abundant in the north, where the land near the ditches is not under cultivation. The species in this small patch includes oxeye daisies, wild chives, common red paint-brushes and white clover.

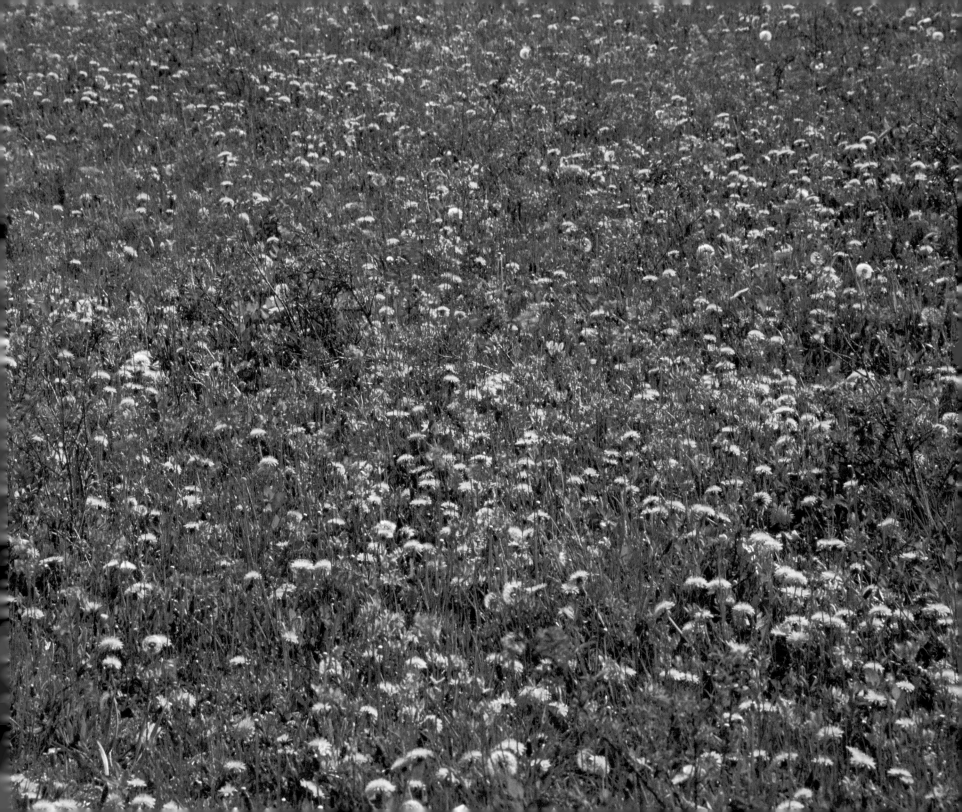

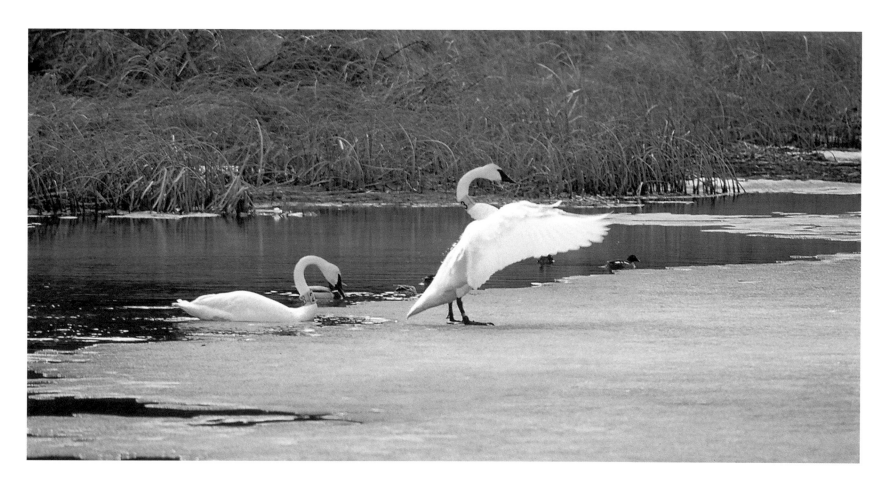

"Hey, where's all the water?" It's early spring, and this pair of Trumpeter Swans is eager and ready to start nesting. They'll have to wait a bit, however, before they can move to the northern part of Elk Island National Park to build the nest. Swans mate for life and both parents tend the eggs and the young. Trumpeter Swans, the largest and loudest of the swans, are also the largest native North American waterfowl. By the early 1900's the Rocky Mountain population was almost extinct but has since recovered and is once again thriving. These birds, however, are extremely sensitive to human disturbance. Several pairs were relocated here from Grande Prairie in 1987 to establish a new breeding colony. Those birds, and a few of their offspring, were collared to help keep track of them. That hasn't been done for many years so this is the only pair of collared swans still nesting in the park. The young are now leg-banded when they can be captured.

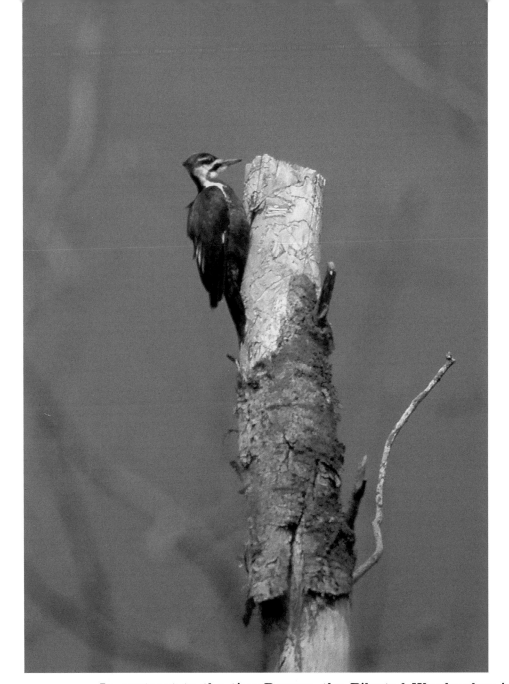

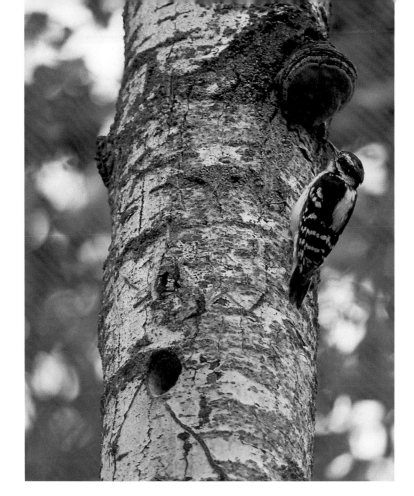

Downy Woodpeckers are common over almost all of North America – found in backyards and parks as often as in forests and orchards. They forage for insects beneath the bark of trees and in the winter are frequent visitors to backyard feeders. This photo was taken in the Chickakoo Lake Natural Area north of Stony Plain. A friend and I set up our tripods and watched for an hour as a pair flew back and forth with insects for the young. The nest was in the hole just below and to the left of the woodpecker.

In contrast to the tiny Downy, the Pileated Woodpecker is the largest woodpecker in North America. (The larger Ivory-billed Woodpecker is thought to now be extinct.) Not common but still seen in many parts of Canada, this bird drills large rectangular or oval holes into standing or fallen dead trees in search of its primary source of food – the carpenter ant. The Pileated Woodpecker can be found in dense, mature forests and in parkland. I photographed this one in Elk Island National Park.

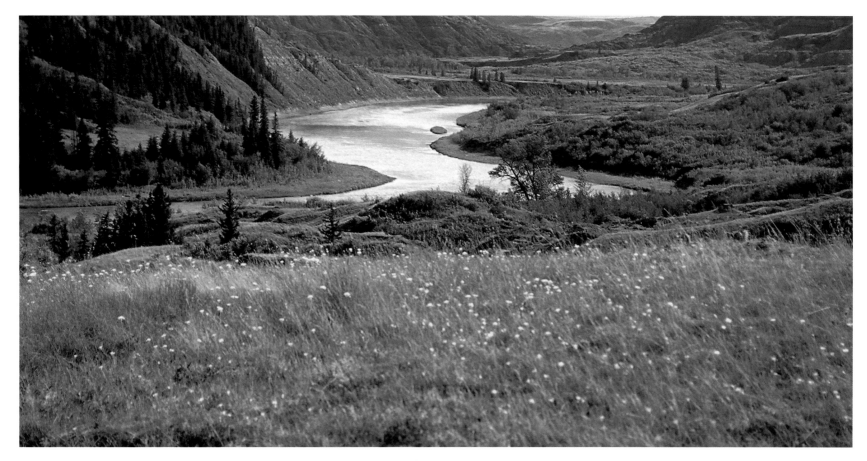

▲ North of Drumheller, along the Red Deer River, there is a small protected area called Dry Island Buffalo Jump Provincial Park. There are no organized activities here, but there is a canoe launch along the river, and plenty of places to walk while enjoying the scenery. It's well worth a visit if you are interested in Alberta history or in the mixed landscape of badlands, grasslands, parklands and forest. The "dry island" is a flat topped mesa rising 200 m. above the Red Deer River. You can also stand at the top of the 3000 year old, 45 m. high buffalo jump, located near the entrance road to the park.

▶ This is another of those photos you feel you can walk right into. The apparent great depth in the photo is again due to the haze and shadow. The image was made in the spring, when all was green and lush, while driving through the Sicsica First Nations southeast of Calgary.

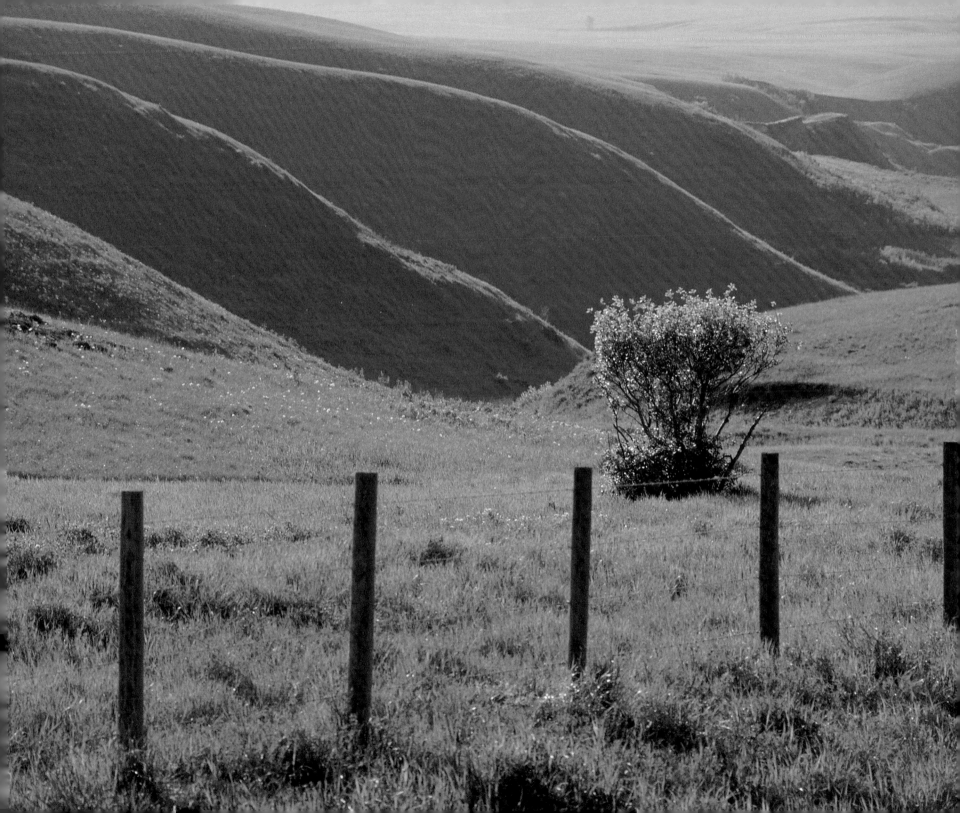

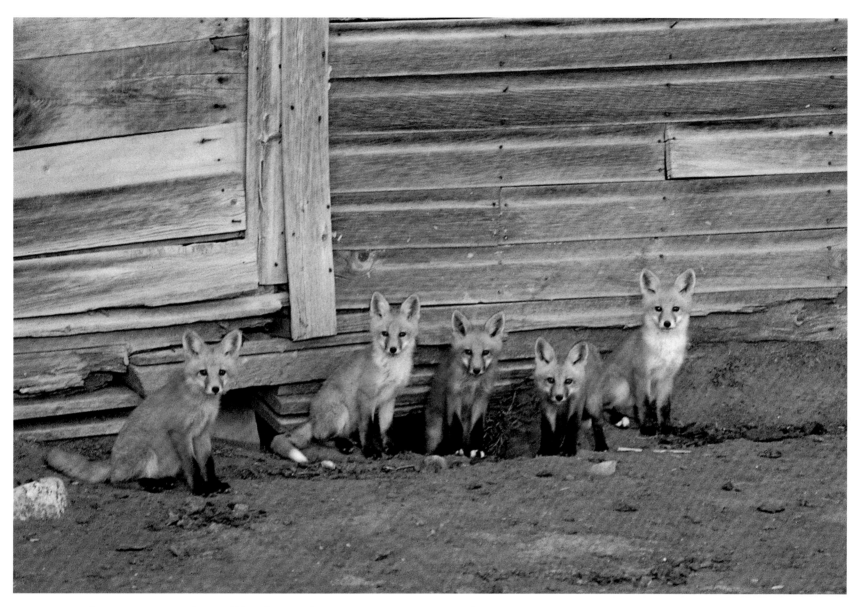

I was approaching Milk River, after a long and lonely drive through mostly empty grasslands, when I noticed a couple of foxes playing in a pasture near the road. I stopped and watched for a few minutes, then got out of the truck and worked my way into the pasture, behind a small hill. At the top of the hill I very carefully crawled far enough, with my camera and telephoto lens in front of me, to get a clear view of the whole family. As sundown was approaching and I was west of them, they couldn't see me as long as I stayed low. There were eight kits in all. Though I watched and photographed for over an hour, till the sun was gone, I could never get all eight to pose together for me.

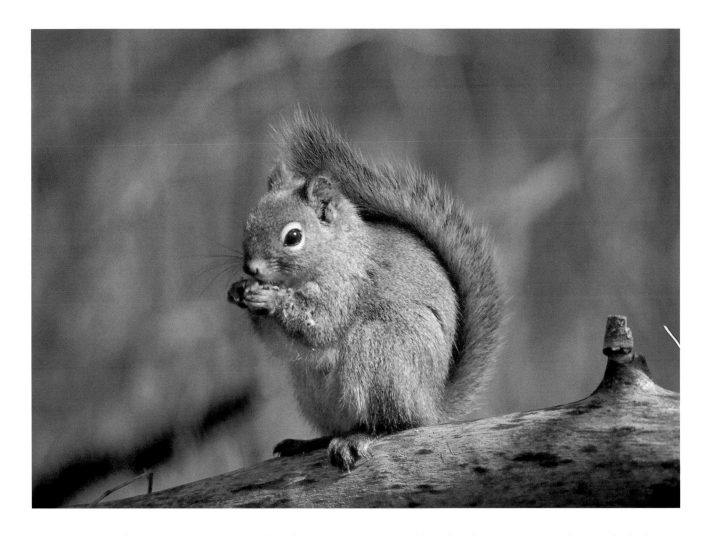

This well groomed Red Squirrel greeted me with a loud and raucous long-winded rant as I finished hiking a forest trail in Elk Island National Park. He sat on a log near eye level for a long time while I just watched. When he had settled down, I slowly set up my tripod and took his photograph. Red Squirrels are common throughout most of Canada. They prefer to eat the seeds from spruce and fir cones but will also eat many other things including mushrooms, buds, berries, insects, fungi and unattended birds eggs and nestlings.

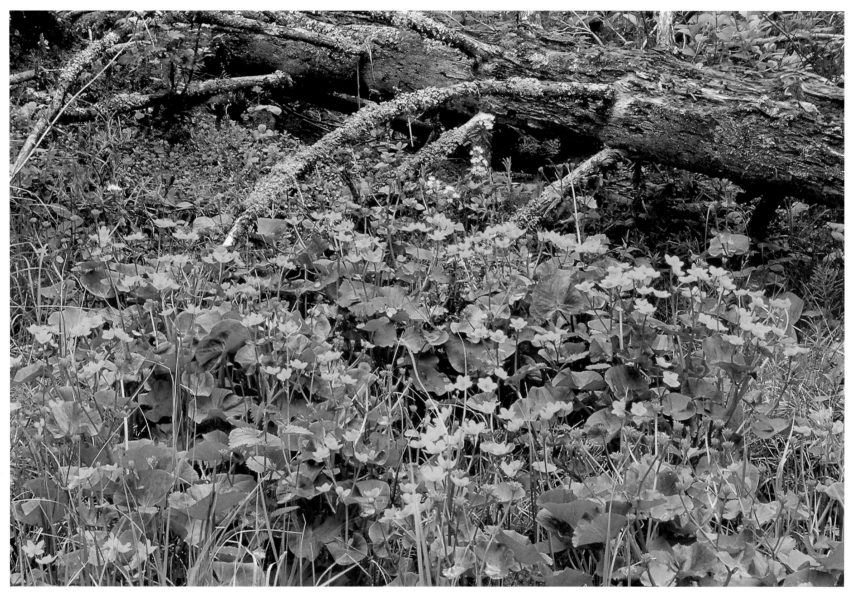

These two photographs were taken in the late spring in the Wagner Bog Natural Area just west of Edmonton. Internationally recognized for its orchids, the area is also rich in many other plant and flower species. Since it is so close to Edmonton it is an excellent haven for "stressed out" city folk. The self-guided Marl Pond Trail takes you deep into a quiet wetland and mixed forest where you can enjoy nature for an hour or two. The bright yellow flowers are Yellow Marsh Marigolds which are abundant in the area. All parts of the plant are poisonous when raw, but are harmless when cooked or dried.

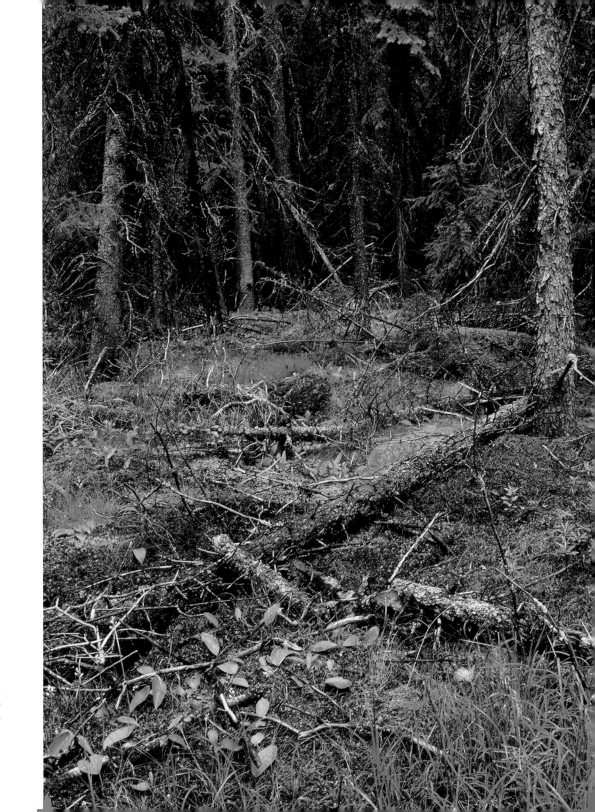

This forest floor still-life is a favourite of mine. I usually find it hard to make a good forest photo, but I think this one works well.

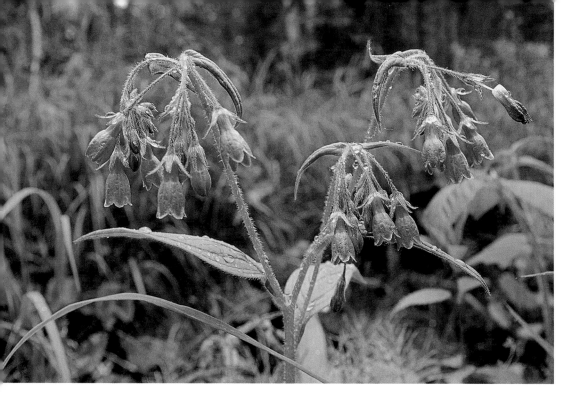

◄ *This photo of Tall Bluebells was also taken in the Wagner Bog area. My friend and I found several large patches with dozens of gorgeous flowers in full bloom. The flower buds are actually pink, but as they open the blossoms turn blue. The Tall Bluebell loves moist conditions and can be found in damp woods and along stream banks in much of the boreal forest and northern parklands.*

▶ *I found several of these Low or Western Larkspur, members of the buttercup family, on a walk I took to the Blackiston Falls in Waterton Lakes National Park. The flowers were a very beautiful deep blue colour, almost purple, which was difficult to capture on film due to the very subdued lighting of an overcast day. All parts of the plant are poisonous to humans and especially to cattle, which is why Larkspur are included in the group of many plants known as locoweeds. Some native Americans extracted a blue dye from the flowers and settlers used the blue extract mixed with a fixative to make ink.*

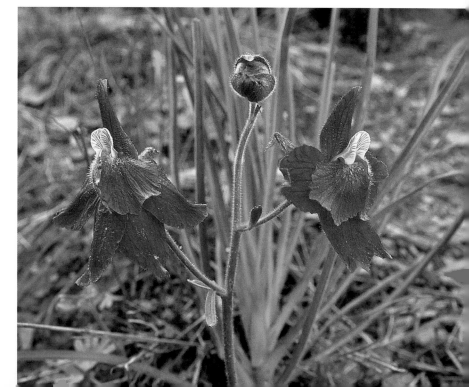

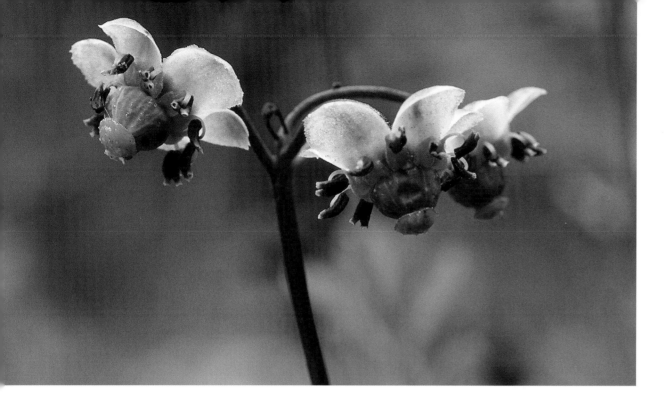

◄ These Prince's Pine or Pipsissewa flowers were photographed in the Cypress Hills in mid July. They are a member of the wintergreen family, are evergreen and perennial, and grow in dry sandy areas of coniferous forests. The plant was named pipsisikweu, meaning "it breaks into small pieces", by the Cree people because they believed the leaves could break up kidney and gall stones. The plant is still used to flavour candy and soft drinks.

▶ Mushrooms are a part of the huge group of organisms known as "fungi", which reproduce by spores rather than by flowers and seeds. They lack chlorophyll, and cannot make their own food, so they obtain nourishment in several other ways depending on the species. Some feed on decaying wood or other dead plant material and some on living plants or animals. Some mushrooms get their nutrients from living trees. In this last case, the mushroom obtains its food from the tree and the tree gets essential nutrients from the mushroom – a benefit to both. Pictured here is a Bolete mushroom, probably a King Bolete. Remember that many mushrooms are extremely poisonous. None should ever be eaten unless they have been identified by an expert and declared safe.

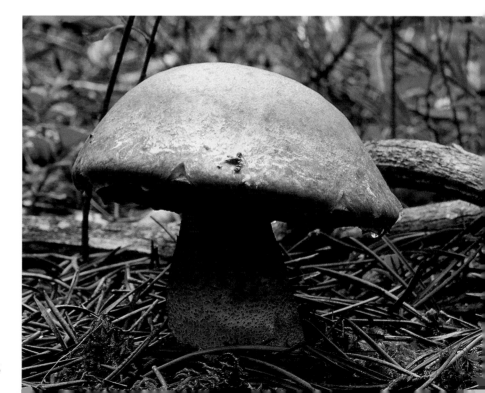

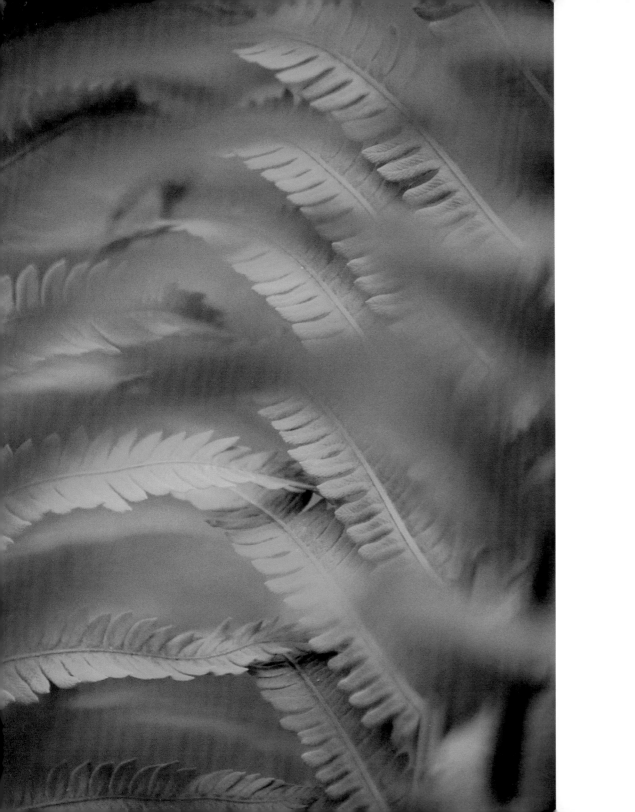

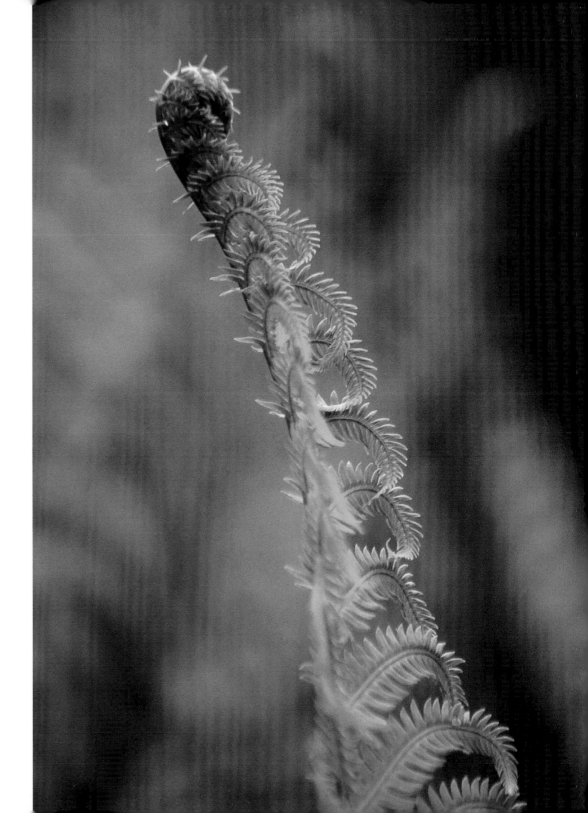

Ferns are not fungi but are part of another non-flowering group of plants which includes mosses, seaweeds and lichens. They also reproduce from spores rather than from flowers and seeds. Ferns are probably the most showy of the non-flowering plants due to their graceful, airy and delicate appearance. They can be found in damp or wet forests, swamps and stream banks throughout much of southern and western Canada. The fiddleheads, (the curled leaf blades), of these Ostrich Ferns are considered the tastiest and the safest to eat of all the ferns. The photo on the facing page was taken with a macro lens looking through many leaves but focusing on the most distant ones.

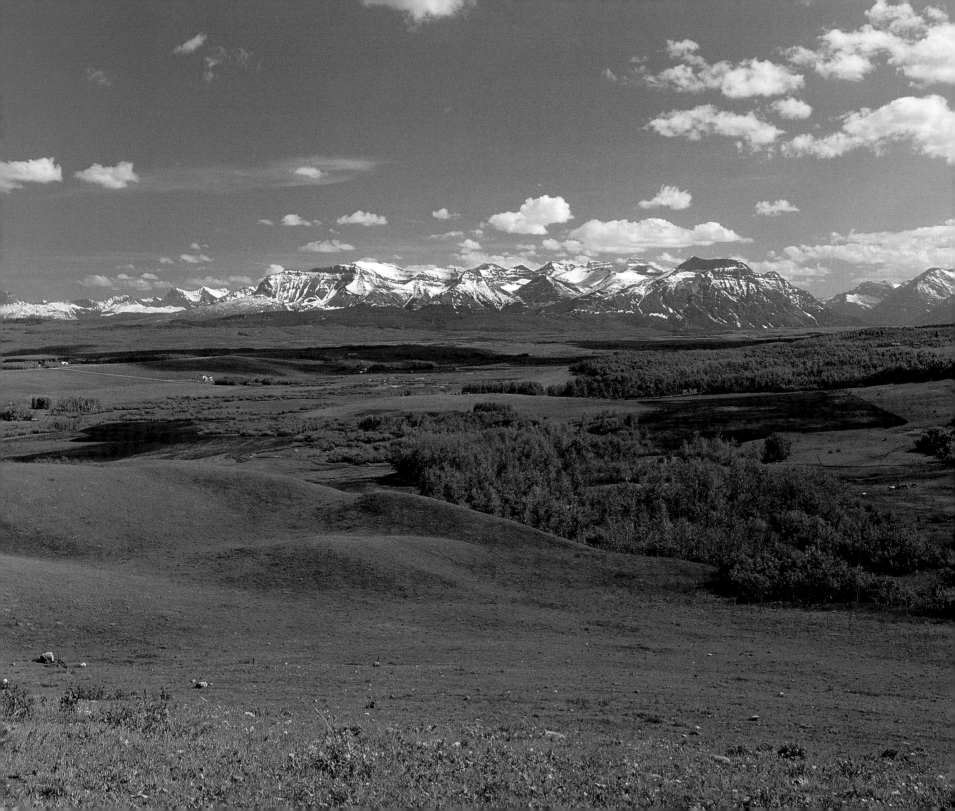

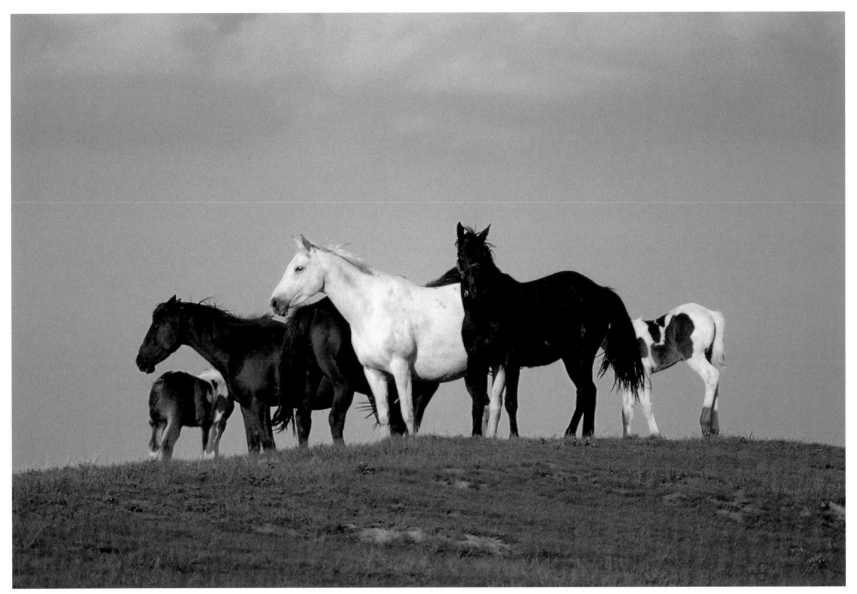

◀ What a grand view of the Rocky Mountains of Waterton Lakes National Park – "where the mountains meet the prairie!" This photo demonstrates dramatically how the mountains here rise directly from the prairie, unlike the many foothills one passes through when approaching Banff or Jasper from the east. The front ranges at Banff and Jasper were heavily faulted, whereas the rock comprising these mountains was thrust up and over much younger layers as a single, intact sheet. Known as the Lewis Thrust, this sheet was more than 6 km. thick and was forced 40 km. northeastward over the underlying layers.

▲ Driving through the Sicsica First Nations, southeast of Calgary, I pulled over suddenly when I spotted these horses grazing in a group on top of the hill. They were so beautiful and so nicely lit by the late afternoon sun that I just had to stop to watch for awhile and take a few photos.

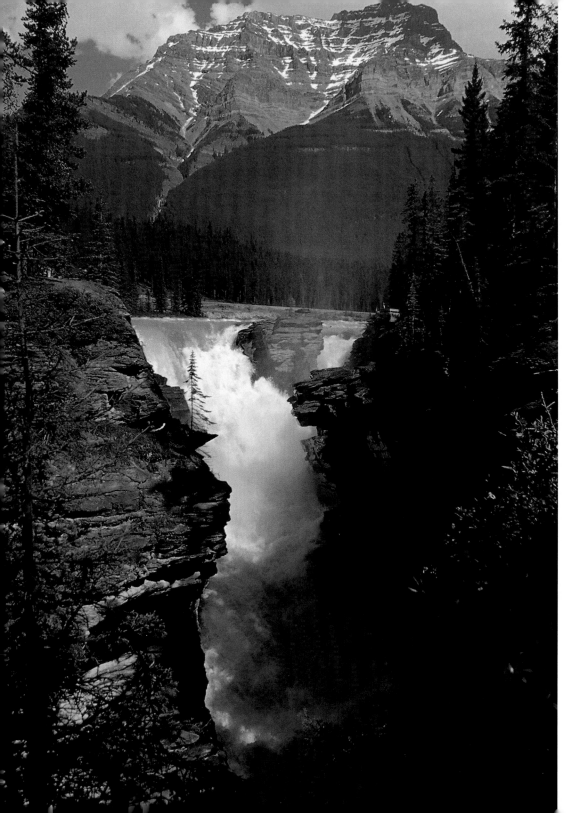

The Athabasca River carries more water than any other river in the Rocky Mountain parks, and in the spring the Athabasca Falls are a raging torrent. The roar of the water is deafening, as it drops the 23m. into the gorge it has cut over thousands of years, and the spray billows up from the depths to dampen everything, including my camera gear. This river is thought to be as old as the Rocky Mountains and has therefore been able to erode them as they have been uplifted. Mt. Kerkeslin (2956 m.) stands guard in the distance.

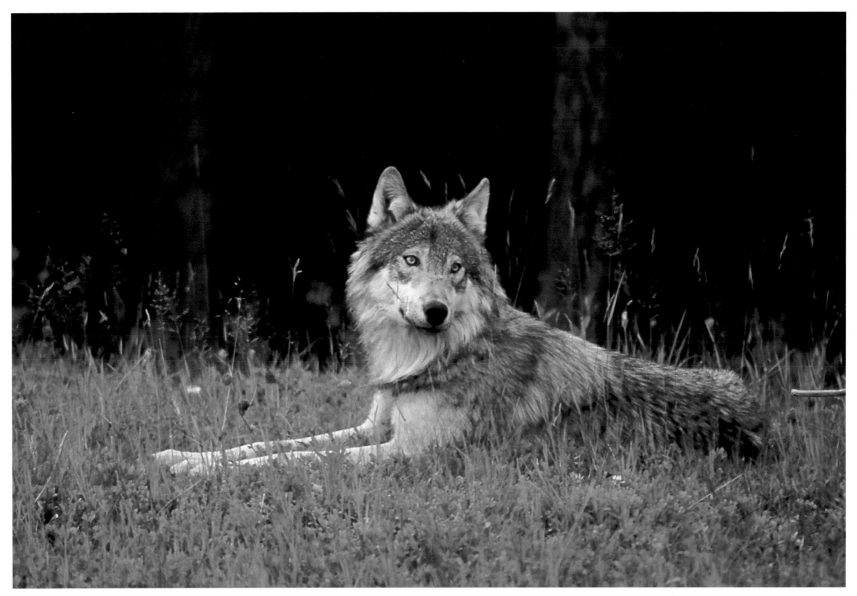

I have always had much admiration and respect for the wolf. I don't think there is a more magnificent or intelligent animal in North America. Once very common throughout Canada, the wolf was exterminated in the Rocky Mountain Parks in the 1950's as part of an anti-rabies program. Over the last 50 years they have returned in acceptable numbers. This fellow found an open meadow near the highway, just north of the Athabasca falls, and was having a peaceful rest until too many tourists like me stopped to watch. What a fantastic feeling to be able to observe a wild, normally secretive beast at such close range!

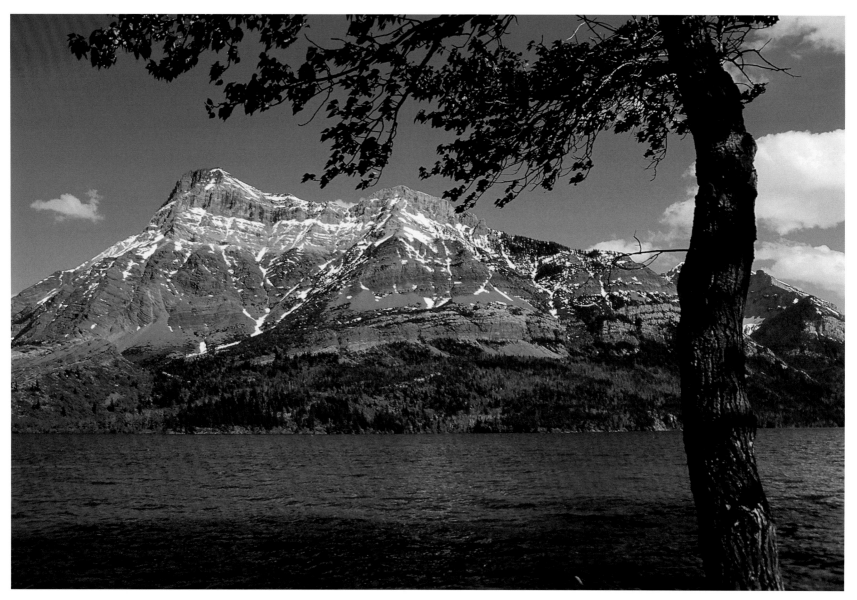

Looking east across Upper Waterton Lake from the campground, we can see Vimy Peak (2379 m.) with remnants of last winter's snow storms clinging to the steep cliffs. Waterton Lake is a popular wind surfing spot because of the strong gales that blow almost constantly through the valley. The average wind speed at the townsite is about 32 km/hr. but gusts of 180 km/hr. have been recorded. Upper Waterton Lake, occupying a trough gouged out of the bedrock thousands of years ago by glaciers, is the deepest lake in the Canadian Rockies – 157 m.

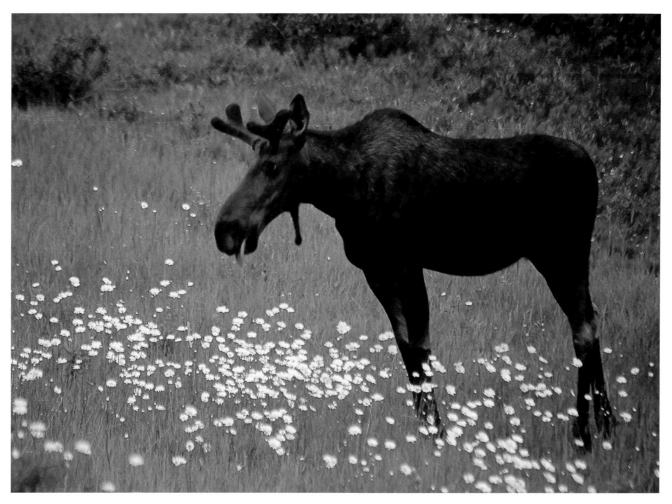

The moose is the largest "deer" in the world. An adult male can weigh as much as 700 kg. and stand 2 m. tall at the shoulder. This fellow is a smaller specimen, and it was spring, so he was not yet "bulked up" after a long, cold winter. Moose are solitary animals for the most part, getting together only during mating. The cow and calf are the only ones to form a social bond. In many parts of the world the main threats to the moose are wolves, snow conditions and disease. In the Rocky Mountain parks one of the greatest dangers is traffic on roads and railways.

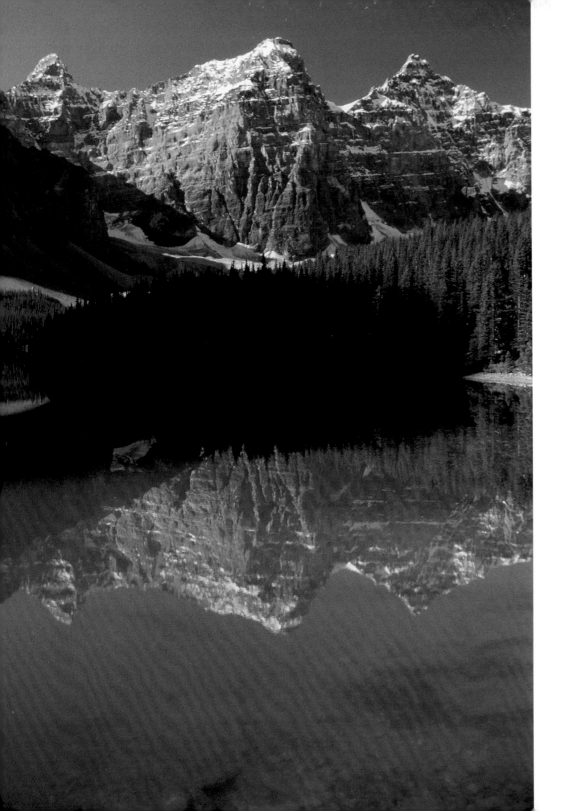

◀ *One of the most beautiful spots in the Rockies, and also one of the most popular, is Moraine Lake and the Valley of the Ten Peaks. The bold, ragged Wenkchemna Peaks (Wenkchemna meaning "ten") were reflected in the early morning calm of the blue-green glacial lake waters. The three peaks seen here include the highest of the ten, Deltaform Mountain, on the right. Morraine Lake formed behind a huge rockpile that was originally thought to be a glacial morraine but a more recent theory is that the dam may have been caused by a huge rockfall off of Mt. Babel.*

▶ *Common Red Paintbrushes almost cover the grassy area near a picnic site, along the southeastern edge of Bow Lake. Crowfoot Mountain rises above the waters on the other side. Bow Lake is a typical glacial lake, fed almost entirely by glacial meltwater.*

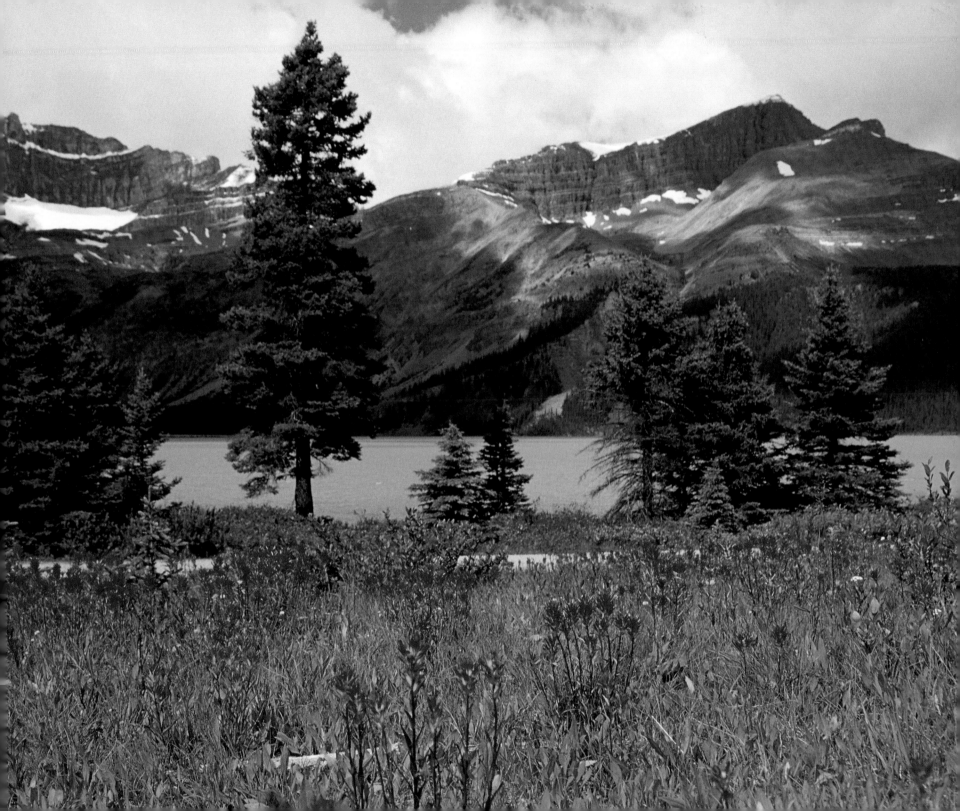

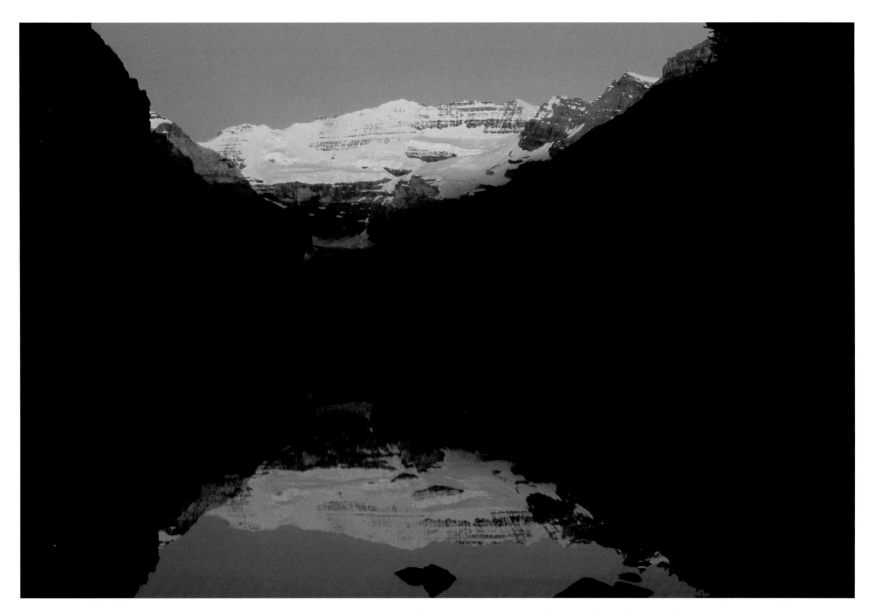

A familiar view of Lake Louise and Mt. Victoria is almost unrecognizable in this sunrise shot, since the lake and foreground are still locked in the shadows of the night. Mt. Victoria (3469 m.) is probably the most photographed mountain in the Rockies, but is much further away than it appears (11 km. to the mountain's peak from the Chateau). It is also one of the most frequently climbed mountains but ascents can be hazardous. Avalanches are common and the summit ridge is less than a metre wide in places.

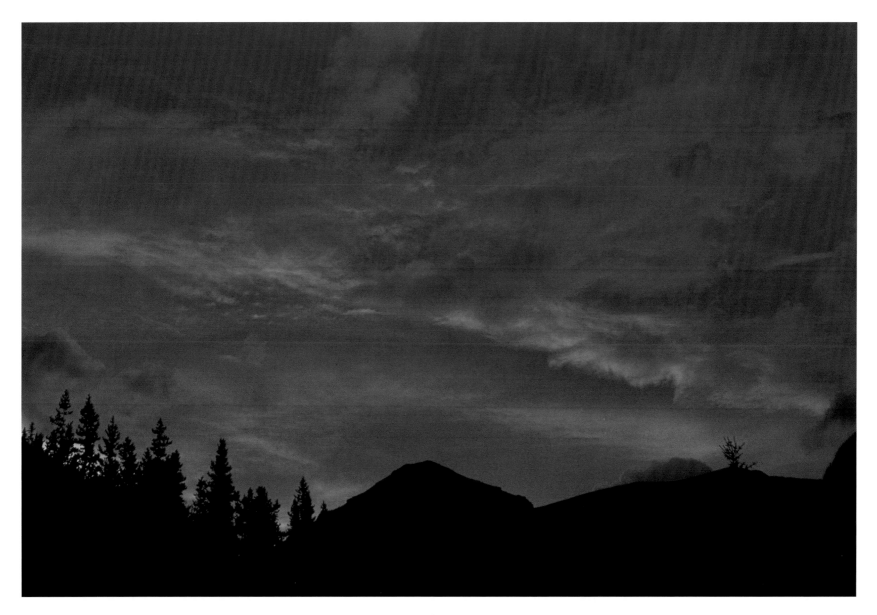

I observed this gorgeous sunrise along the Akamina Parkway in Waterton Lakes National Park, on the beautiful drive to Cameron Lake. My habit on photo shoots is to be up and on the road, or on the trail, well before the sun rises. This is one of the reasons why. It's always a good idea to keep an eye on where you have come from as well. If I hadn't been looking back occasionally, I probably would have missed this sight altogether.

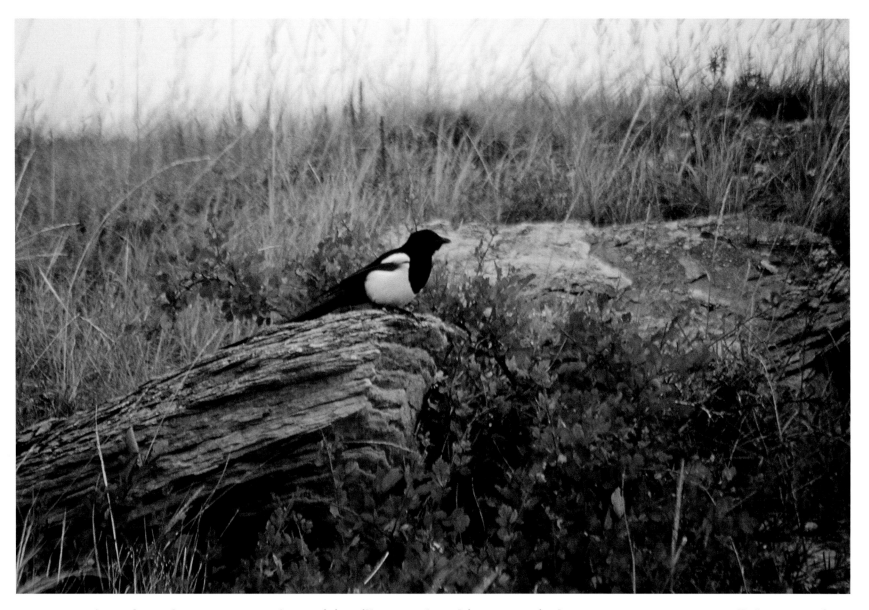

Any of us who grew up on the prairie will remember this very typical pasture scene as we recall those carefree, hot summer days of our childhood. I took this photo while hiking in Writing-on-Stone Provincial Park in the very south of the province, along the Milk River. Despite their annoying and aggressive behaviour, Magpies are quite striking in appearance. They are, however, extremely hard to photograph because of their contrasting black and white colouring.

This was another one of those times when I said to myself, "Do I really want to take a photograph of pond scum?" It just doesn't seem right to be trying to make something beautiful out of something so disgusting. Despite my misgivings, I think the colours work, and this **is** a very typical prairie summer scene.

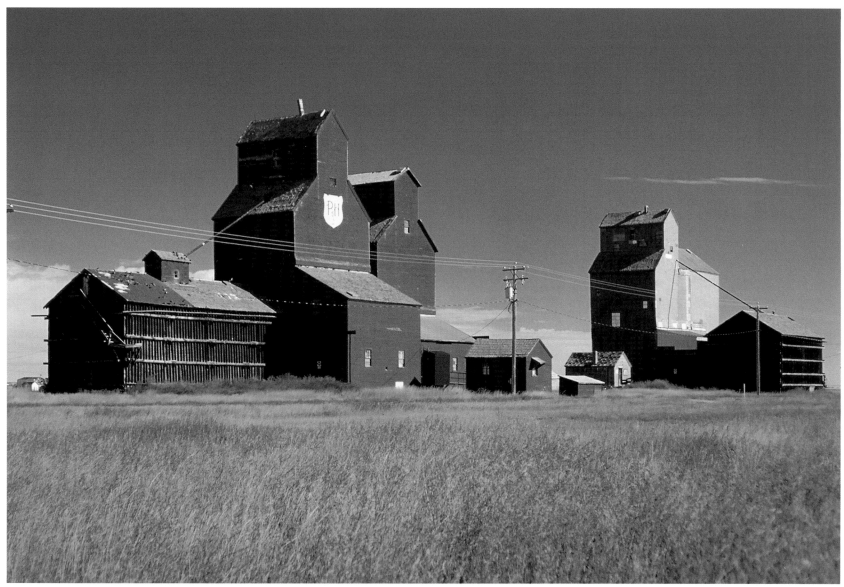

The familiar prairie elevator has been disappearing rapidly over the past few years, so it is rare to find even one in a town anymore, let alone more than one. My discovery of these two typical old giants was purely by accident, as the town they are in is not even on the map. The town is Chin, just east of Coaldale, on #3 Highway east of Lethbridge. My understanding is that the town was essentially deserted with almost all of the buildings removed or demolished, before someone decided they didn't want to see it disappear. Several houses have been moved back in and a few new ones are being built. The town is still extremely tiny but it is alive. No one seemed to know why these two elevators had been left standing when towns all around had lost theirs.

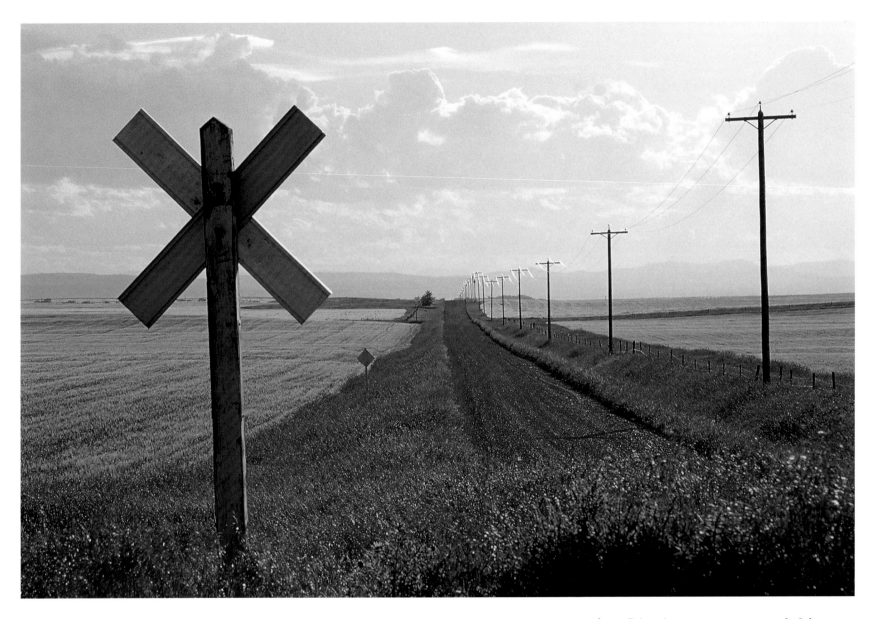

The slightly different perspective of this prairie scene caught my attention. It's almost a portent of things to come. The railway tracks are there but we don't see them; at a time when rail tracks across the prairies are disappearing quickly. I originally took the photo because of the sun glinting off the telephone lines dipping between poles, but I like the analogy of the disappearing railway tracks better.

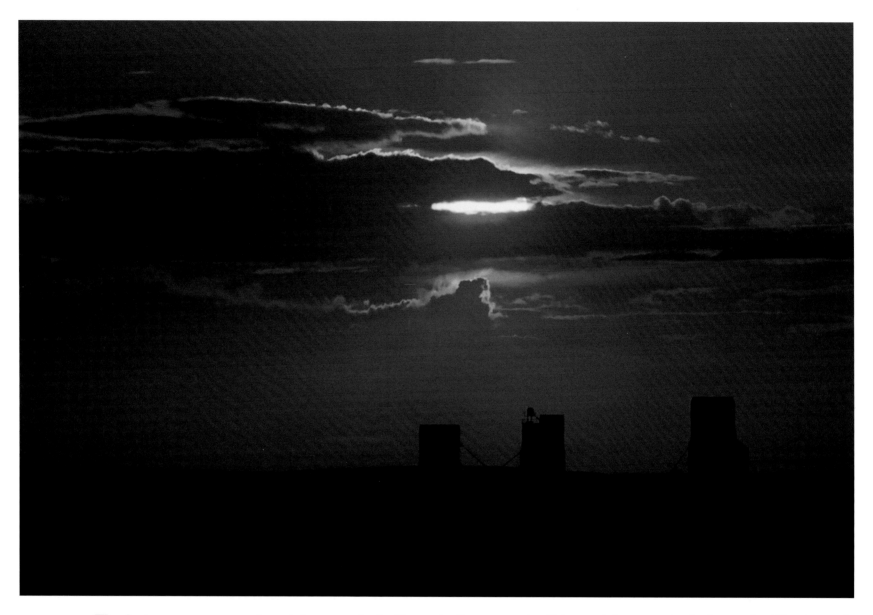

The hot summer sun almost burns a hole through the paper in this prairie sunset photograph. The town is Hussar, straight east of Calgary, where I waited for several hours for this sunset, hoping it would be worthwhile. It's so difficult to find a town anymore with more than one traditionally hip roofed elevator. When I do find one I am willing to spend a lot of time trying to use the silhouettes to my best advantage.

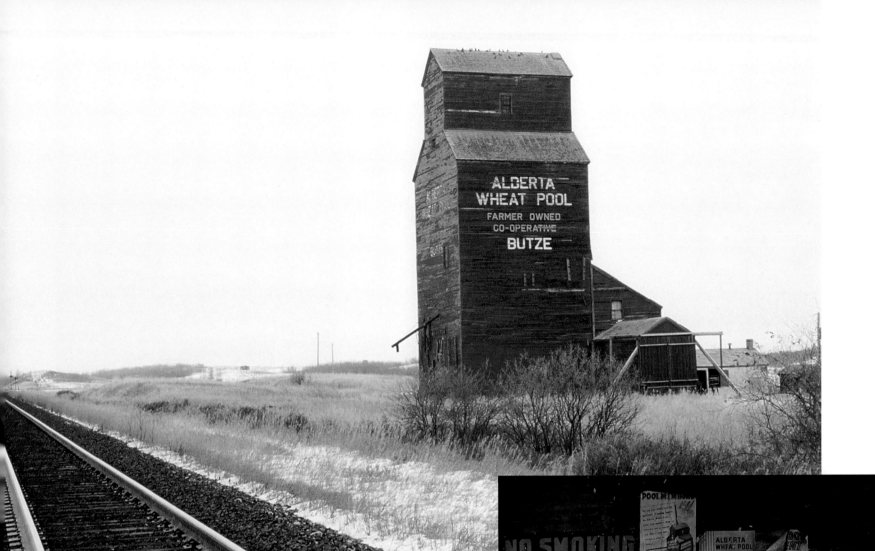

The Butze elevator stands all alone now, near the Saskatchewan border, south of Lloydminster. The lock had been broken off the door so I peeked inside, immediately sliding back in time to the 50's and the small central Saskatchewan town where I grew up. Once there were seven elevators in that small town – now there is one. The memories all came back; the scale platform in the floor with the large grate for the grain to fall through, all the wooden and galvanized pipes and chutes, the big galvanized bucket augers, and the small one-man cage-elevator to take the operator to the top of the bins – and **there** – all the old notices and flyers tacked to the inside walls. I spent a long time just standing there, looking, before I even thought of taking a photo.

43

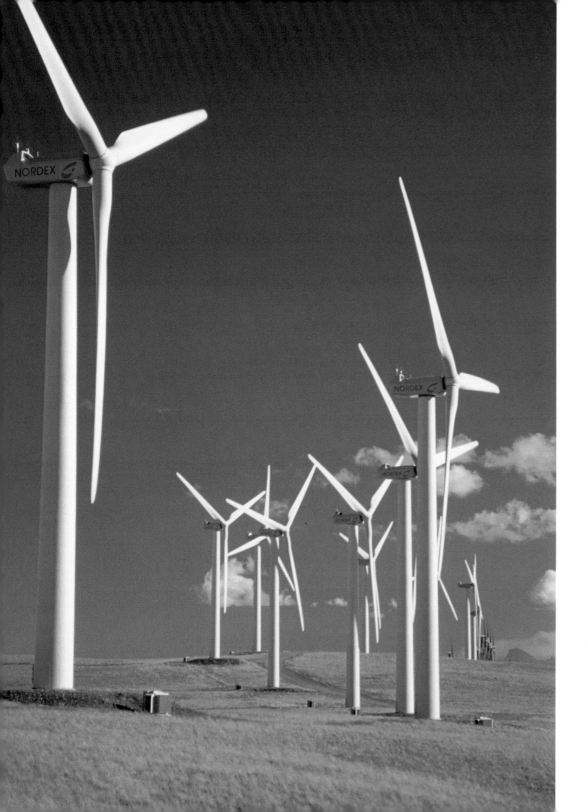

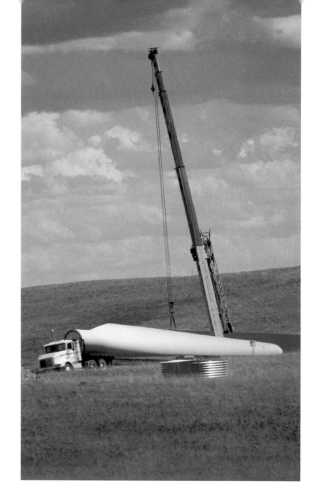

For many years Alberta has been leading the way in wind turbine power generation. The first wind turbines were brought on line in 1993-94 to become Canada's first commercial windplant. Since then there have been hundreds more turbines built, resulting in huge savings to the environment. Each of the initial 52 turbines has a 33 m. diameter rotor mounted on a 24.5 m. tower and can operate in winds of 14 to 97 km/hr. The blades are capable of operating at variable pitch for optimum aerodynamic performance at a broad range of wind speeds . Each turbine reduces carbon dioxide emission levels by 1000 tonnes per year, and sulfur dioxide emission levels by 2.6 tonnes per year. The small photo above shows one 16 m. turbine blade being unloaded from a semi-trailer truck during construction of more new turbines.

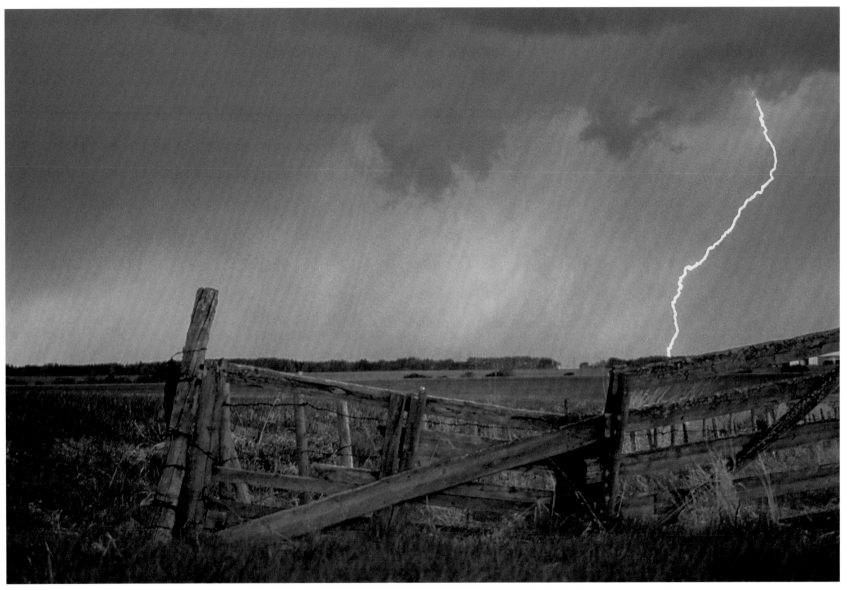

There are roughly 2000 lightning storms in progress worldwide at any one time, creating as many as 5 million bolts of lightning per day. While driving south along Highway #2 near Red Deer, I noticed that the lightning strikes off to the west seemed to hang in the air much longer than normal. Sometimes the strikes, each of which are only milliseconds long, will move up and down the same channel as many as 10 or 20 times – as happened in this case. The resulting extended length of the flash allows a photographer with quick reflexes to catch the last of the strikes on film. I quickly found this old fence along a side road and set up my tripod low in the ditch, beside the truck, to get this unique shot.

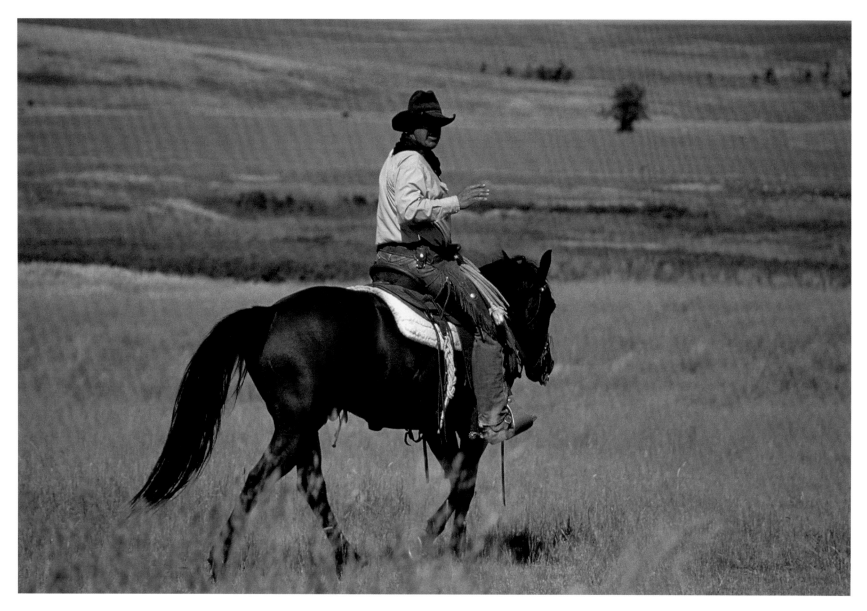

More often these days, it seems that cowboys aren't really cowboys. Many don't ride horses during roundup or cattle drives anymore – they use motorbikes or four-wheelers instead. It was great to see Ken Jensen and a fellow cowboy rounding up a small herd on horseback near the road to Police Outpost Provincial Park, in the southwest corner of the province. I watched for awhile and took photos as they rode off into the distance.

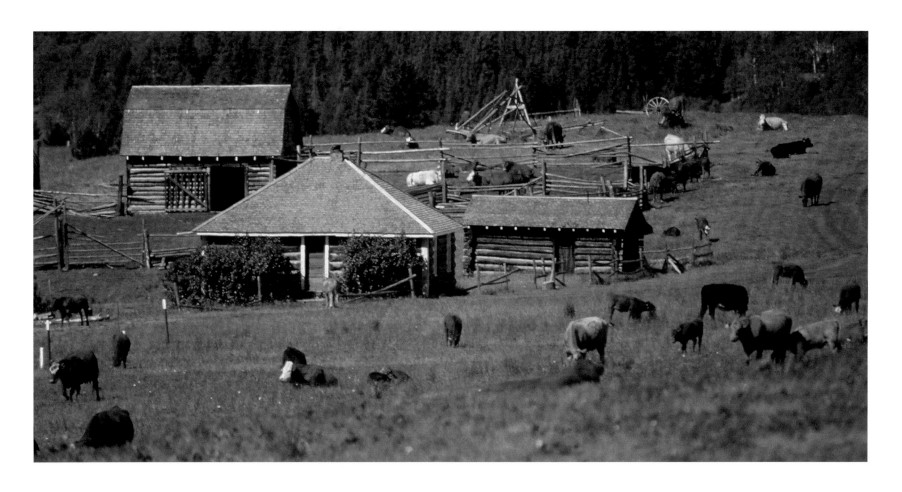

This old log ranch grabs my attention every time I travel Highway #22 south of Longview. It sits in a clearing just off the road as the highway climbs over a hill. Something about it draws me in! This time there was a large herd of cattle grazing around the old buildings which definitely made it worth stopping for a photo session.

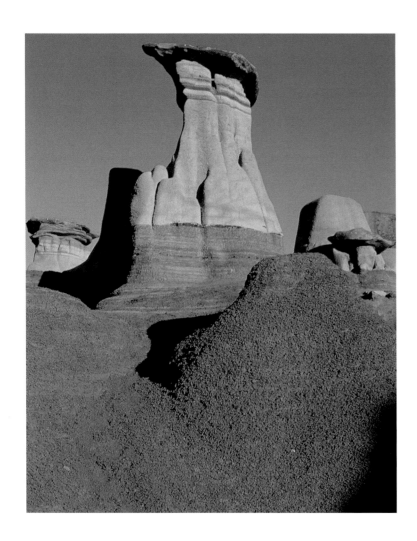

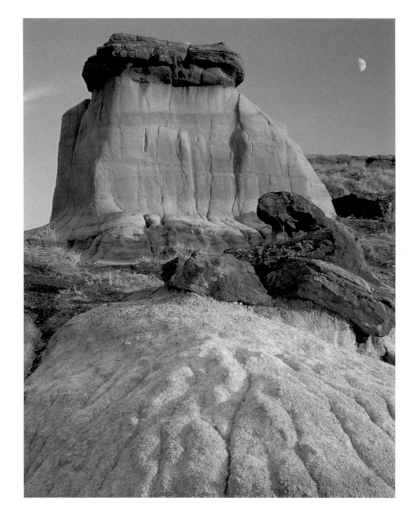

Hoodoos are a part of the Badlands landscape – a very unique and interesting part. They are formed when hard rock lies over top of a softer rock. As the formation erodes, the hard layer partially protects the softer layer by forming a cap above it. The formation in the photo above is part of a very well known group of hoodoos near Drumheller. The one in the photo on the right is near the campground in Dinosaur Provincial Park, which was declared a UNESCO World Heritage Site in 1979.

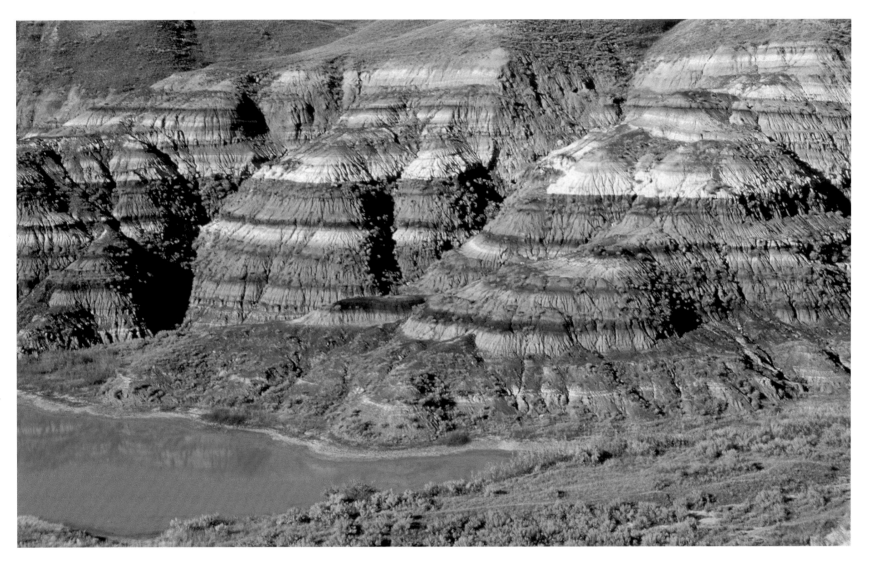

 As in both of the photos shown on the facing page and the above photograph as well, taken near Drumheller, most of the badlands in Alberta are found along the Red Deer River. The Red Deer has carved a large gash across the prairie from the city of Red Deer to the South Saskatchewan River northeast of Medicine Hat, exposing layers of rock more than 70 million years old. Some of these rock layers contain a priceless bounty of prehistoric remains. There are fossils from 35 different dinosaurs in Dinosaur Park alone – the most dinosaur fossils in any one spot on earth.

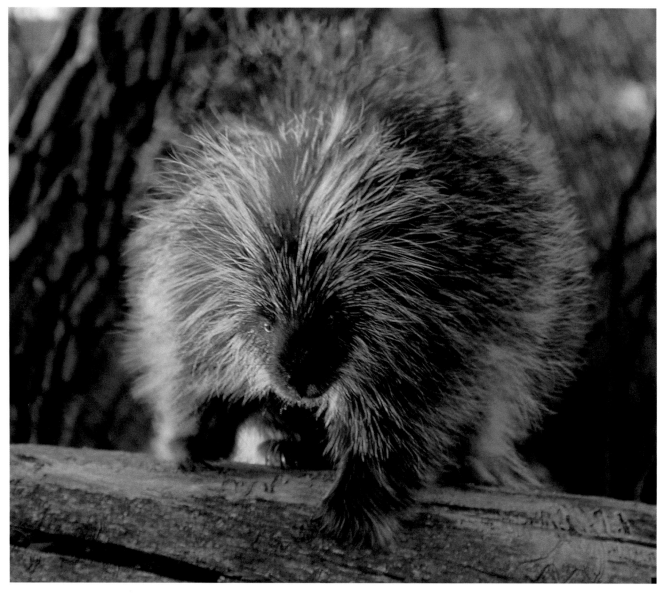

Porcupines are large, nocturnal rodents usually seen during the day only as a dark, round shape high in a tree. They are very slow moving but have an advantage against predators that makes up for that – their bodies are almost totally covered with 30,000 modified long, stiff hairs known as quills. The quills are barbed and loosely attached to the skin so they become instantly imbedded in any attacking predator which touches them. Porcupines cannot throw their quills as is commonly believed, but the tail can be swung violently at an attacker, inflicting sometimes fatal injuries. A face and throat full of quills can lead to blindness or starvation.

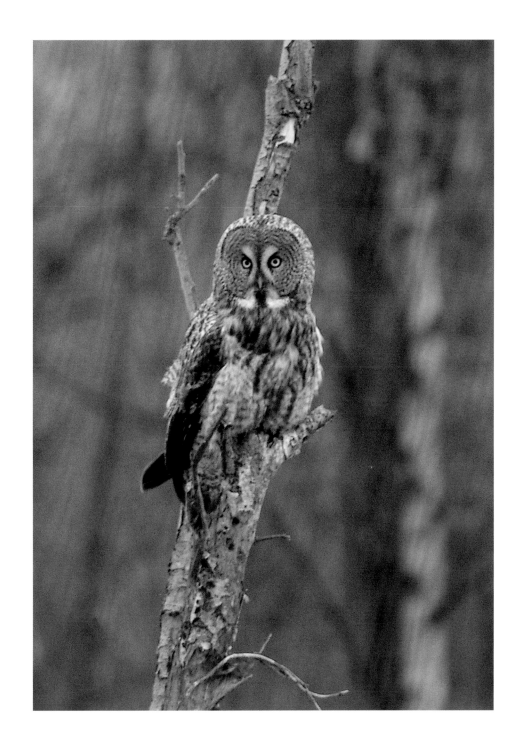

The Great Gray Owl is North America's largest and can be differentiated from most other owls by size and lack of ear tufts. Yellow eyes distinguish the Great Gray from its smaller and more common cousins, the Barred Owl and the Spotted Owl. It is mostly nocturnal but also hunts at dawn and at dusk over clearings and wooded bogs, in boreal or dense coniferous forests. I found this one in Elk Island National Park.

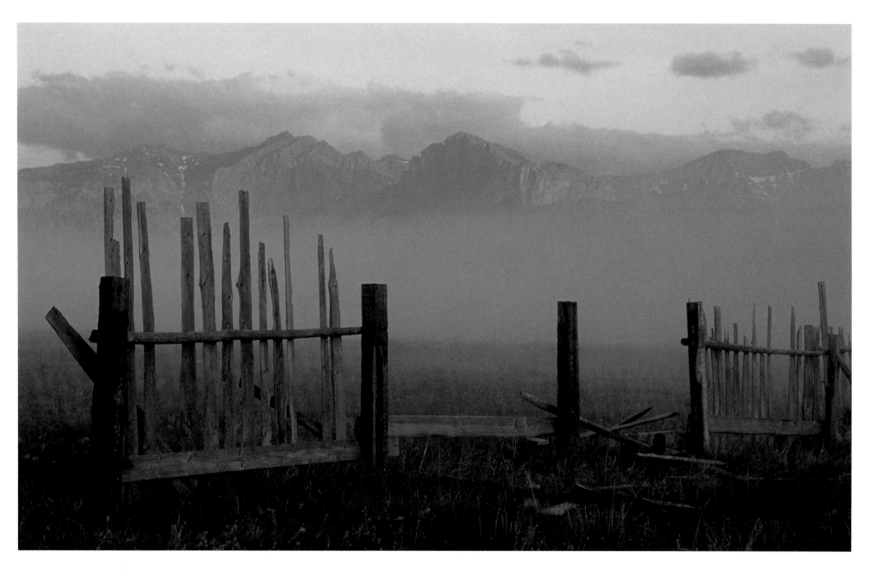

During my summer travels around Alberta a couple of years ago, while staying with my sister in Calgary, I rose before 5:00 a.m. so I could be in the mountains before sunrise. I didn't make it as far as the mountains because I found this pasture and old slat windbreak near the Bow Valley Provincial Park before I got there. I took photos and waited in the fog for the sun to rise, then took more photos as the fence shone like burnished gold. Personally I like the soft, muted purples in this image better than the stronger, brighter colours in the photos that I took later on that morning.

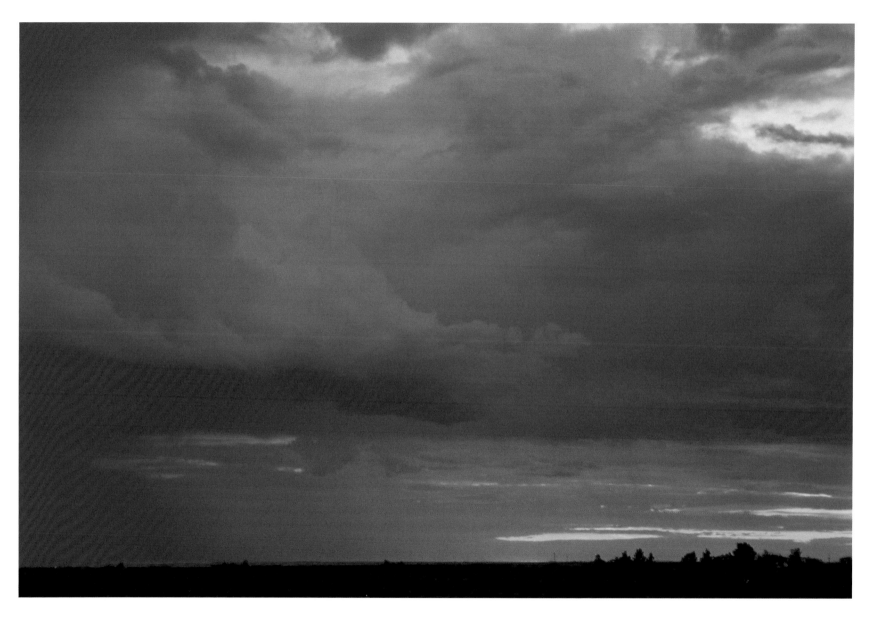

In spite of the fact that sunrises and sunsets are so easy to capture on film, I still like the infinite variety we get on the prairies. The reds and golds of the actual sunset in this photograph are secondary to gorgeous blues in the sky above.

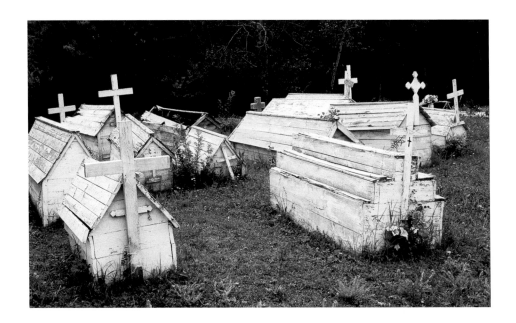

When the missionaries first came to the north in the late 1700's, they began to convert the Dené people to Christianity. As a result, the Dené began to bury their deceased loved ones in cemeteries. The Spirit Houses which they built over the graves combined the Christian concept of burial with the Dené concept of shelter for the afterlife. The newer Spirit Houses in the photo above are in the Eleske Shrine cemetery, about 40 km east of High Level, which dates from the 1930's. The older cemetery in the photo on the right is at Indian Cabins, just south of the N.W.T. border. At one time there was a mission there but most of the population has relocated. The cemetery has not been used in many years. If you look carefully you can see a log placed between the two large trees in the back of the photo. This log would have been the coffin for a baby or small child and is thought to have been placed there in the very early 1900's.

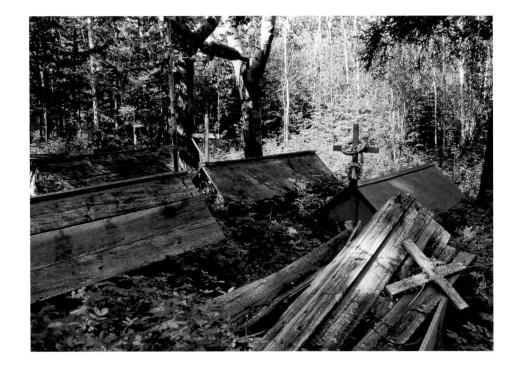

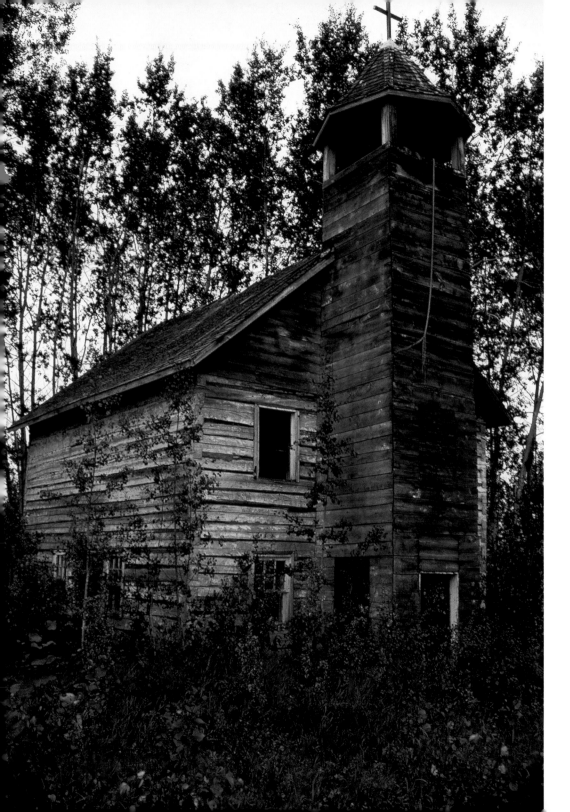

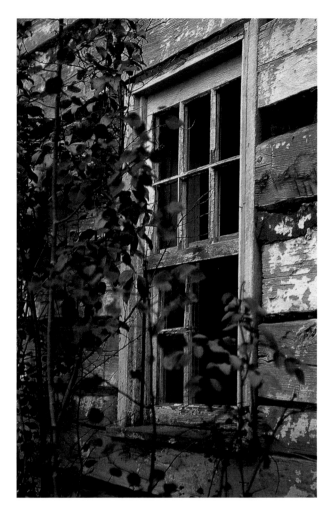

This old log church is at North Vermilion, just across the Peace River from Fort Vermilion. It was also known as "Buttertown" because there used to be a butter factory here in the early years. There was once a Catholic mission here and the church was built in the early 1900's, but most of the population now lives and works across the river in Fort Vermilion. The bell was removed from the church in the 1980's but the cemetery is still in use.

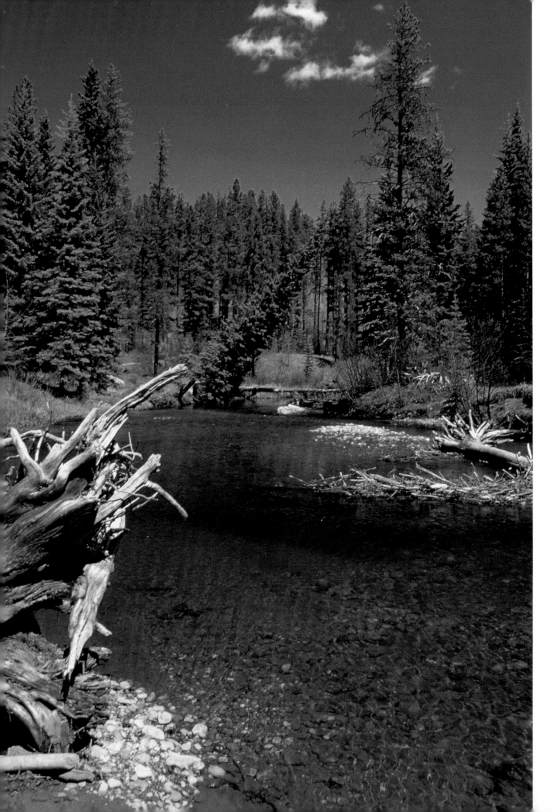

◀ This pretty little river is the Pembina, which flows out of the foothills south of Edson. I was driving the back roads, cross country from Drayton Valley to Hinton, when I started to feel drowsy. I pulled off the road at a little campsite by the river, took this photograph, and then had a nap.

▶ While spending some quality time hiking in the foothills and mountains of Waterton-Glacier International Peace Park, my wife and I found this colourful creekbed just below a lovely little waterfall. The photo was taken from a precarious perch on a log overhanging the creek, looking straight down through the water to the brightly coloured, sunlit stones on the bottom.

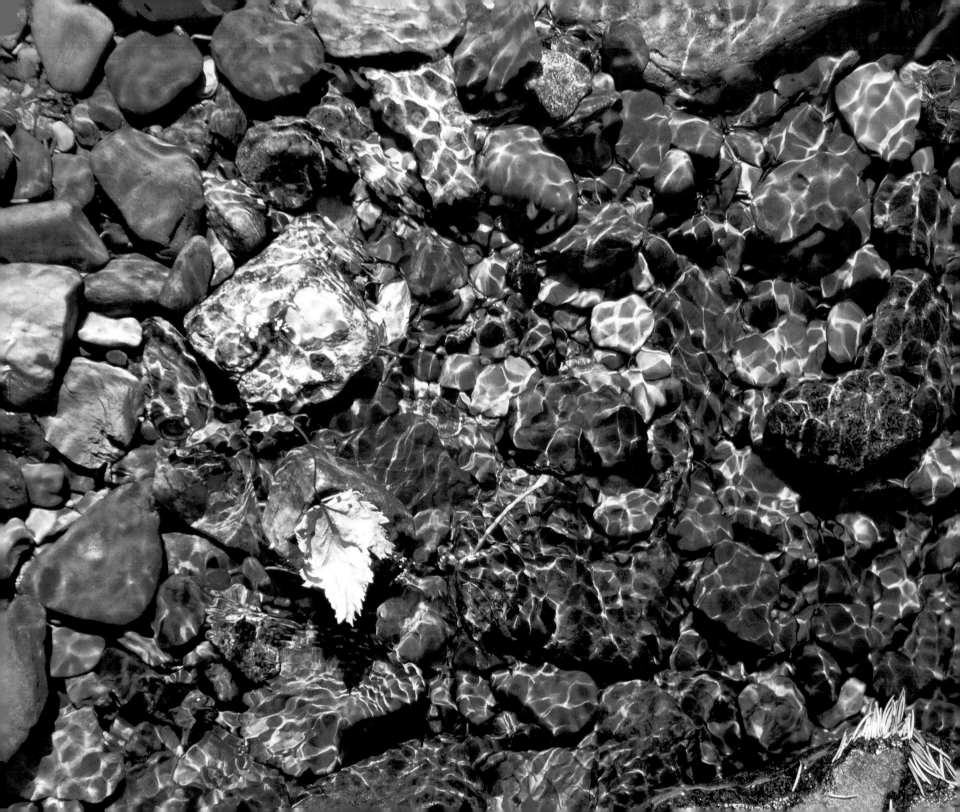

▲ *Just east of Slave Lake, along Highway #2, there is a huge area of forest that was burned out a few years ago, allowing the fireweed to take over. Fireweed is appropriately named, as it is one of the first plants to colonize an area after a forest fire, but it also grows in open woods and waste areas. Because it is so abundant and has such a long flowering season (July through September), it is an important source of nectar for honeybees.*

▶ *Fireweed is also common along roadsides and open areas in the mountains, wherever the soil has been disturbed. Here it mingles with Yarrow along the banks of Tangle Creek, just below the falls. As well as being used often by native peoples to make tea, the flowers, tender young plants, and leaves were added to soups, or cooked and seasoned and eaten like any other greens. Fireweed is the floral emblem of the Yukon Territory.*

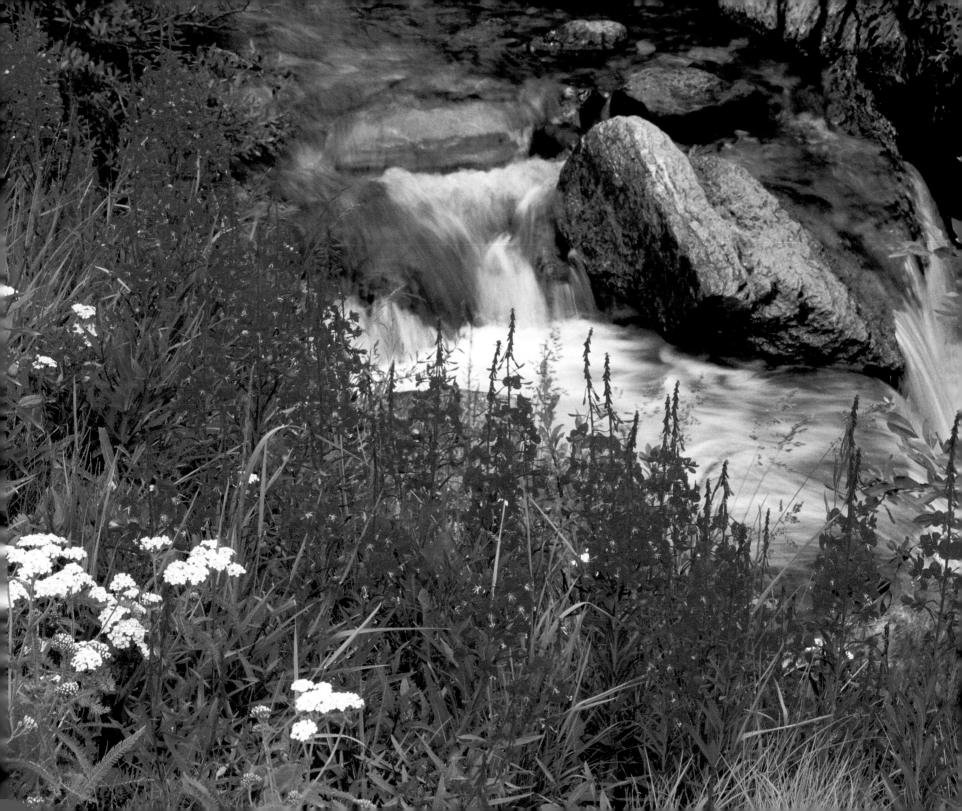

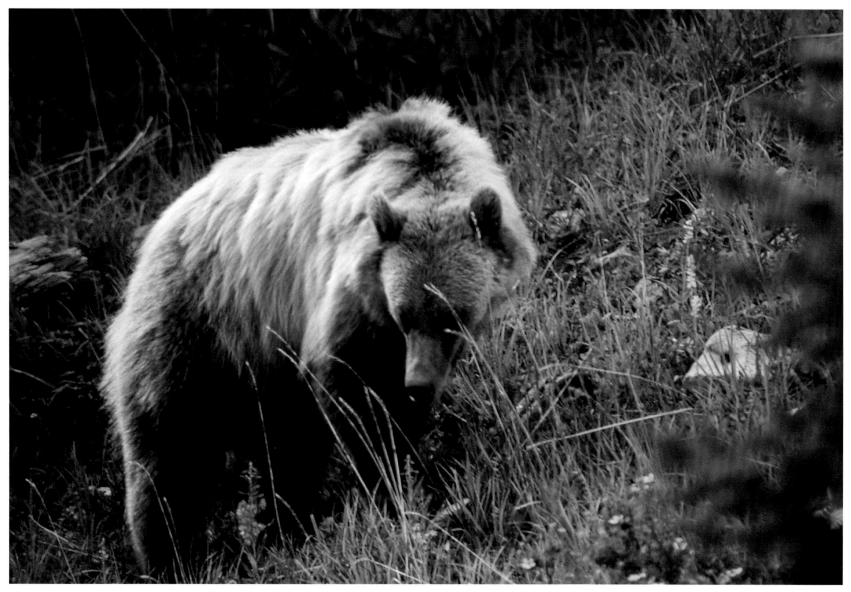

The Grizzly Bear is, to most people, the ultimate symbol of wilderness. I found and photographed this one near a picnic site in the Highwood Pass area of Kananaskis Country. Contrary to their fearsome reputation, Grizzlies are 90 % vegetarian and are usually only dangerous to humans if they are surprised, cornered, or with cubs. The Grizzly can be readily distinguished from the Black Bear by the shoulder hump, the slightly upturned nose, and the long front claws which are always visible. Bears spend almost every waking moment (up to 18 hours a day) searching for food to tide them over the long period of winter dormancy. During the peak feeding time, in August, Grizzlies can consume as much as 36 kg of food a day.

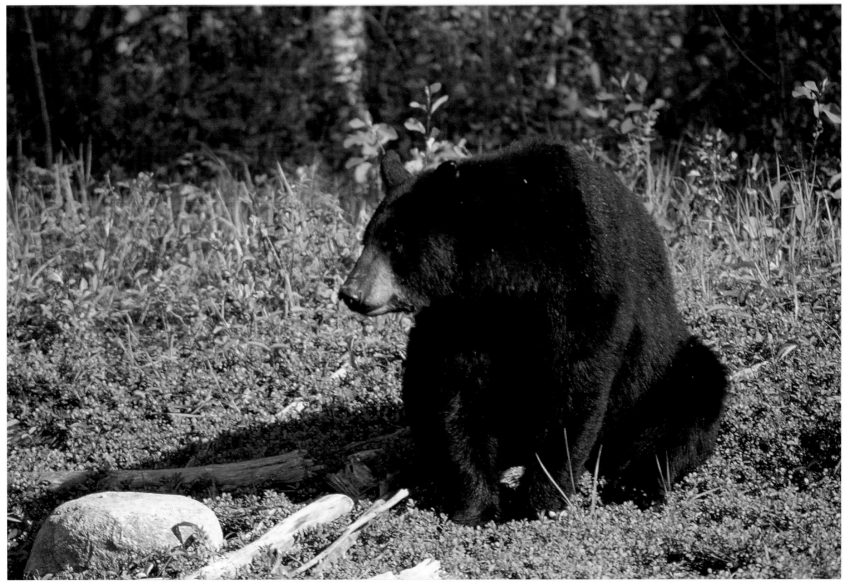

Black Bears are smaller than Grizzlies and not as heavily built. They are more likely to be spotted by humans as they prefer the montane valley bottom habitat to the alpine meadows and avalanche slopes more often frequented by Grizzlies. The Black Bear is not always black. The coat can range from black to brown to cinnamon. Unlike the Grizzly, the Black Bear can climb trees easily and will use this skill to avoid danger. All bears go into a form of hibernation in the winter. Their body temperature drops about 5° C, but their metabolism does not slow much, so they can be awakened quite easily. They neither eat nor expel body wastes during hibernation. Although mating occurs in late spring and early summer, bears experience "delayed implantation", meaning that the fertilized egg does not develop until it implants in the uterus in November or December. Thus, fetal development takes place for only 6 to 8 weeks before the cub is born in the den, in January or February, weighing only a few hundred grams and completely helpless.

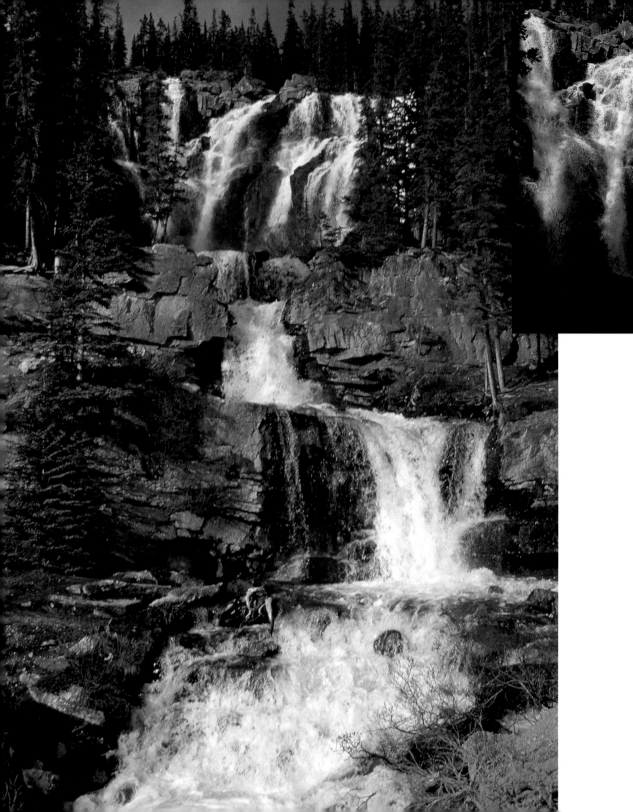

Tangle Falls is one of the prettiest waterfalls along the Icefields Parkway between Lake Louise and Jasper. It tumbles out of Wilcox Pass between Tangle Ridge and Mount Wilcox, dropping down over several steps to the highway. The Tangle Creek trail climbs up to Wilcox Pass from the south side of the creek. Another short trail leads up the north side of the creek for a closer look at the top of the falls.

Maligne Canyon, just east of Jasper along the Maligne Lake road, is the longest and deepest limestone canyon in the Rockies, and probably the most interesting. The Maligne Valley is a hanging valley, meaning that glaciation has left the floor of the Maligne at its mouth somewhat above the floor of the Athabasca Valley into which it drains. Over the last 11,000 years the Maligne River has cut its way down through the 120 m. difference in elevation to produce the narrow, 55 m. deep, 2 km. long gorge. A trail follows the length of the canyon with spectacular views of the river roaring through very narrow breaches and over numerous waterfalls, some as high as 23 m. (For a more placid and seasonally different view see page 112)

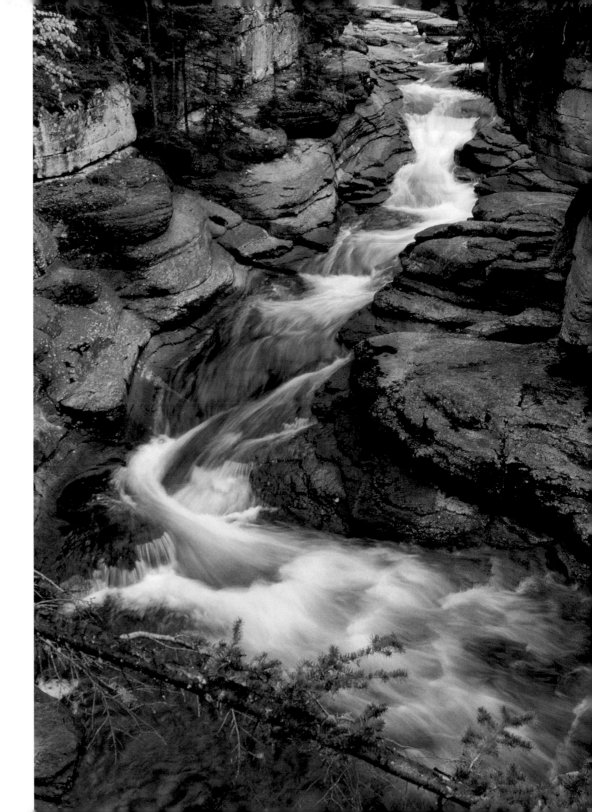

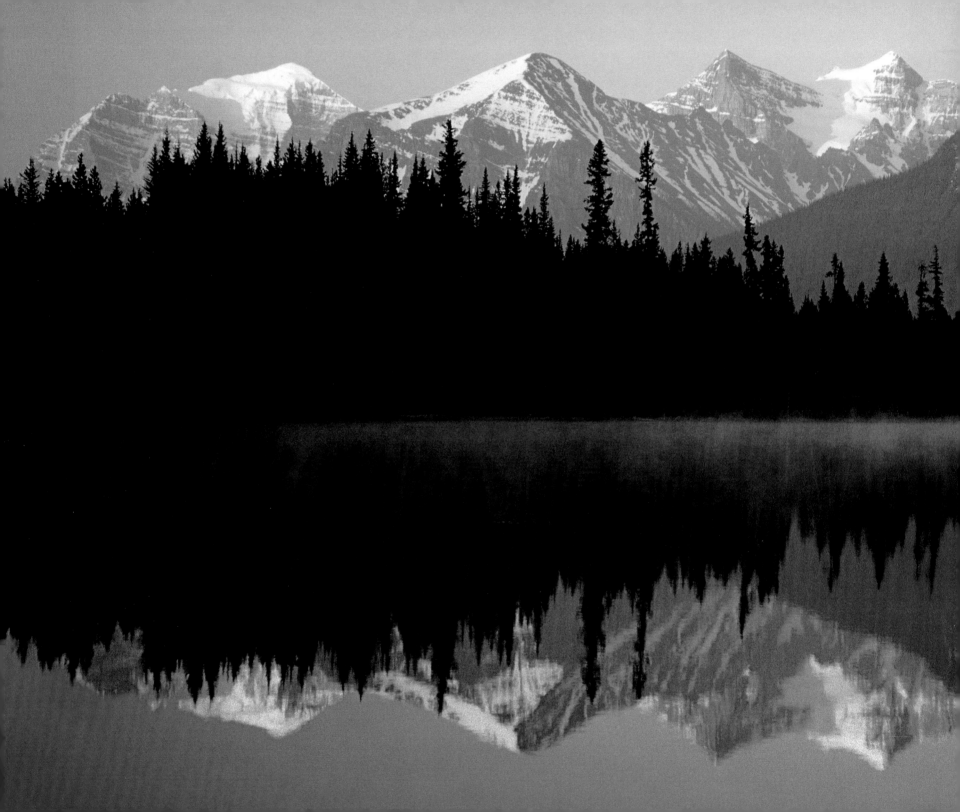

◀ One of my reference books suggests that the sunrise at Herbert Lake is much more interesting than the one at the more famous Lake Louise, so on my next trip I made a point of being at Herbert Lake first thing in the morning. I spent a couple of hours taking photos from various angles, but was quite disappointed with what I saw. I often forget that you never know what you have until you see the processed film. I believe this is one of the best sunrise photos I've ever taken.

▶ Up well before sunrise and into Jasper National Park through the east gate, I drove past Pocahontas and Disaster Point, all the way to Talbot Lake. The light was beautiful but I did not see much to catch my attention until I turned around and drove all the way back to this small pond east of Pocahontas. The perfect reflection of Roche Miette, combined with the dead tree trunks in the water, made it very worthwhile getting my feet wet, on the short hike out onto a long peninsula, to take this photo.

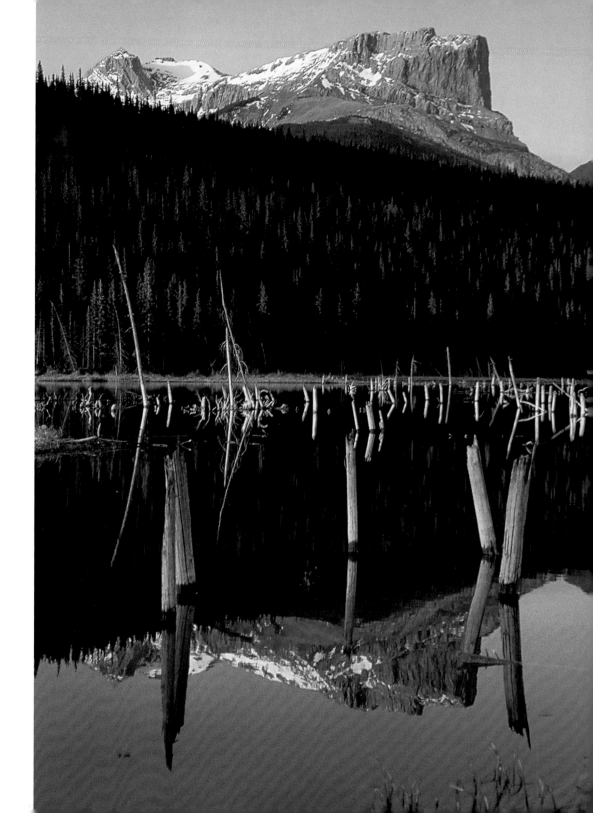

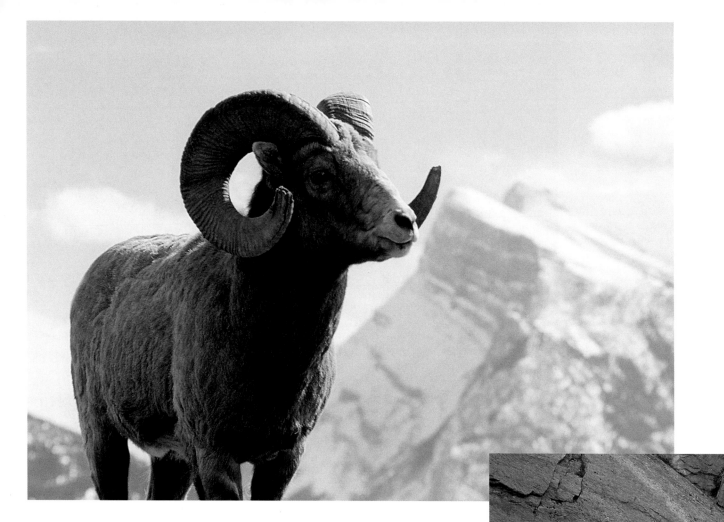

Rocky Mountain Bighorn Sheep, the symbol of Banff National Park, are found throughout the Rockies. Mostly frequenting rugged mountain slopes and alpine meadows, there are also some populations living in rolling foothills. Bighorn rams are especially noted for the fierce battles they engage in during the autumn rut. They charge headlong at each other, meeting horn to horn with a mighty crash. The biggest danger to the Bighorn Sheep these days is not hunting, but traffic on the highways and railways. Both Bighorn Sheep and Mountain Goats are extremely sure-footed on rugged ground and steep cliffs like these at Disaster Point, Roche Miette.

During the months of July and August the alpine and sub-alpine slopes are covered with a carpet of beautiful flowers. This photo was taken along the trail which climbs the north side of Parker Ridge. This area is moister and less windy than the ridge itself. Some of the many flowers on show were Sub-alpine Fleabane, Sulfur Paintbrush, Yellow Arnica, and Grass of Parnasus.

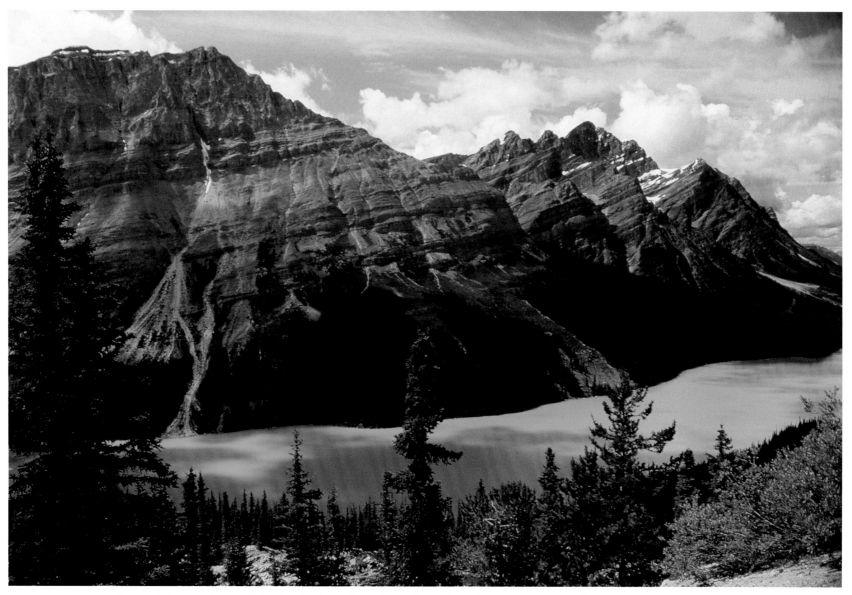

For the millions of tourists that visit the Canadian Rockies each year, the stop at Bow Summit and the view from the Peyto Lake lookout are essential parts of their trip. Bow Pass (2069 m.) is just below the tree line and is the highest point on a Canadian highway that is kept open year-round. It separates waters that flow south to the South Saskatchewan River system from waters that flow north to the North Saskatchewan River system. Peyto Lake is a typical glacial lake fed by meltwater from the Peyto Glacier. As the lake ice melts in the spring, the water appears dark blue, but as glacial meltwater adds more and more "rock flour", the colour changes to the striking blue-green for which the lake is famous.

Even though Johnston Canyon is a very popular tourist stop and sometimes very crowded, it's still worth a visit. The canyon trail climbs gently for 2.7 km. to the Upper Falls, at the deepest part of the canyon (30 m.), and can be navigated even in winter. The travertine wall opposite the Upper Falls is a favourite ice climbing location. The Lower Falls, pictured here, are just 1.1 km. from the trail-head and well worth a stop.

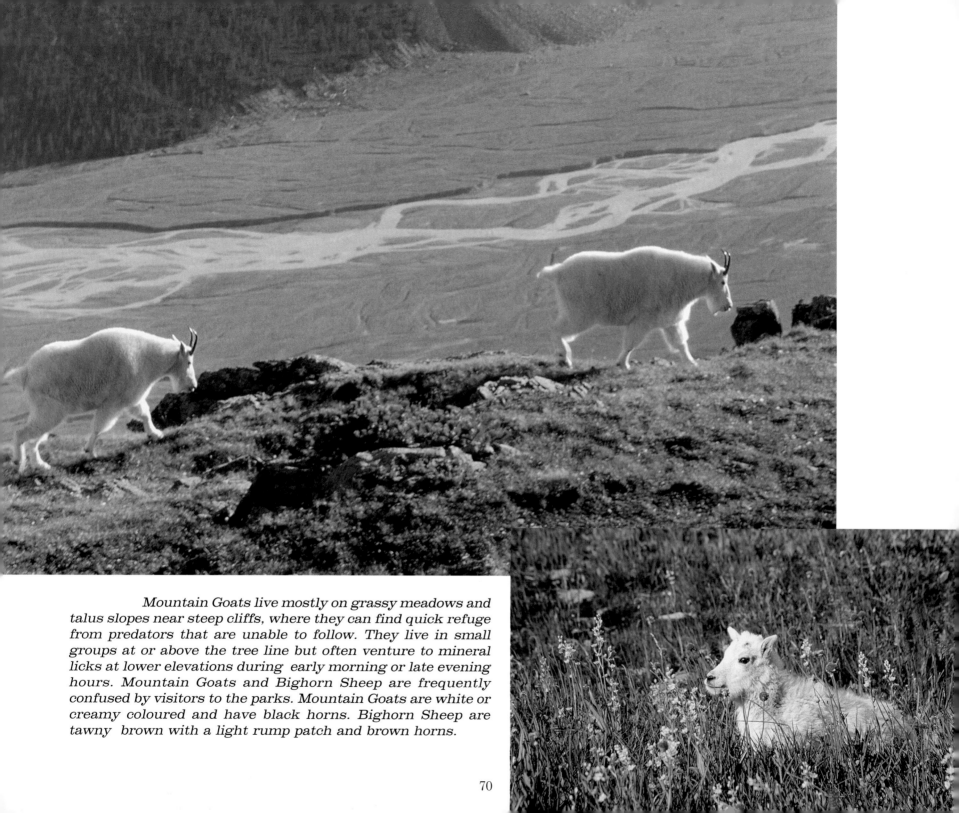

Mountain Goats live mostly on grassy meadows and talus slopes near steep cliffs, where they can find quick refuge from predators that are unable to follow. They live in small groups at or above the tree line but often venture to mineral licks at lower elevations during early morning or late evening hours. Mountain Goats and Bighorn Sheep are frequently confused by visitors to the parks. Mountain Goats are white or creamy coloured and have black horns. Bighorn Sheep are tawny brown with a light rump patch and brown horns.

◄ *These beautiful little flowers are Red-stemmed Saxafrage. It took great effort to identify them, as none of the plant guides I have were very helpful. After e-mailing the photo to five different sources I received two positive identifications. The red "beaks" in the centres of the flowers are actually seed pods.*

► *As with all alpine plants, the Alpine Butter-cup grows close to the ground to avoid moisture loss and ravaging from the incessant winds.*

▼ *Alpine Forget-me-nots grow as low cushion-like plants in clumps, and in open, rocky places high in the mountains. This photo was taken on Parker Ridge on a very normal, windy day, so it was difficult to get a sharp image.*

▼ *The Western Pasque Flower is similar to our very familiar wild crocus, but grows on mountain slopes and meadows at high elevations. This photo was taken at Agnes Lake, above Lake Louise. All of the other photos on this page were taken on or along the trail to Parker Ridge, near the Columbia Ice Fields.*

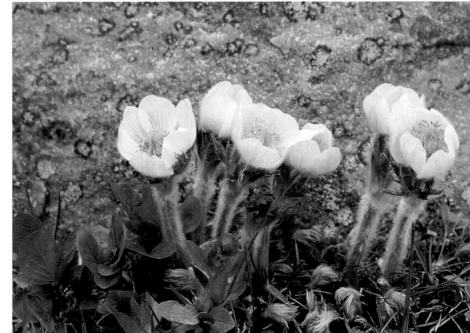

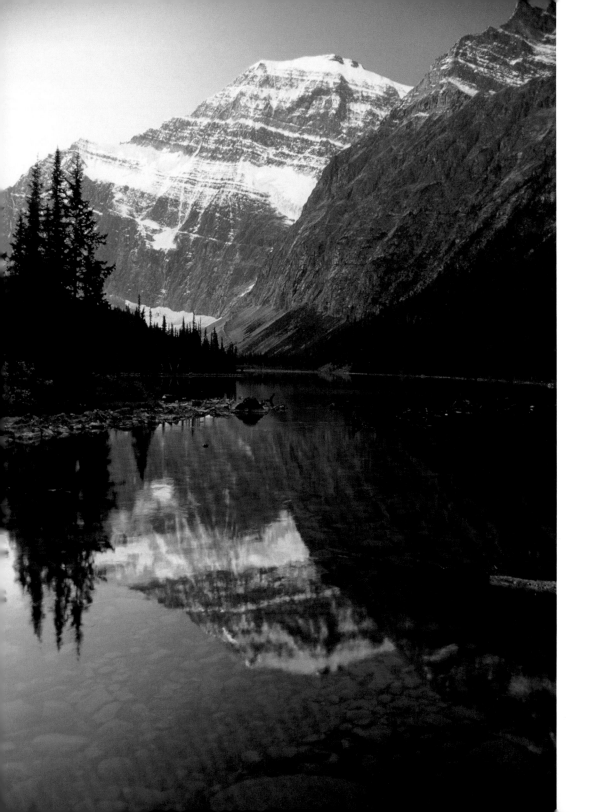

I was a bit disappointed with the sunrise photos I took from Cavell Lake because I was expecting to catch glorious early morning colour on Mt. Edith Cavell (3363 m). It was a bit late in the season, however, and the sun was too far south by the time it rose above the Maligne Range to the east. Most of Mt. Edith Cavell stayed in shadow, but everything worked out just fine, as the calm lake reflected the mountain beautifully, with just a hint of sunrise colour on the peaks.

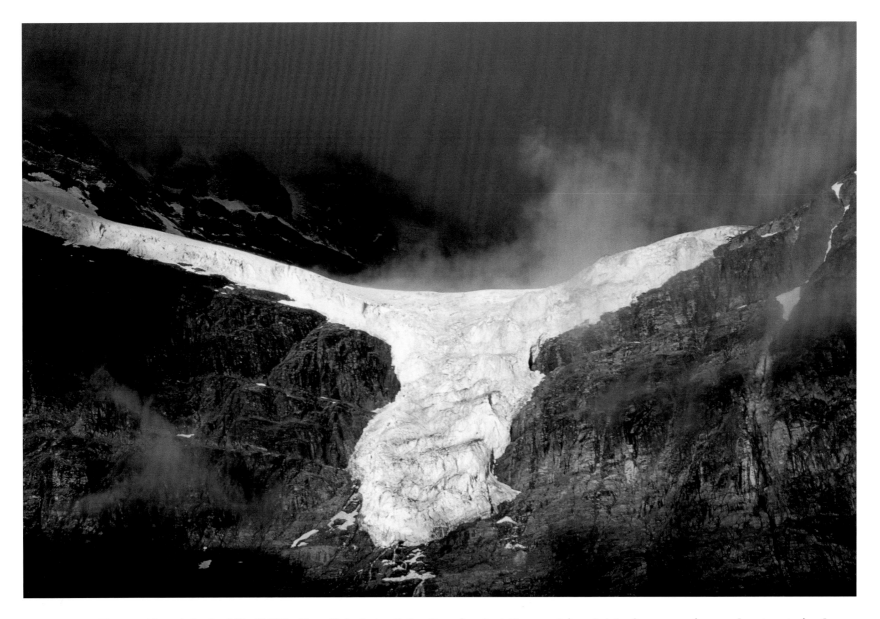

On another trip to Mt. Edith Cavell in late July, I arrived at the parking lot before sunrise and set out, in dense fog and cloud cover, on the 1.5 km. walk to the base of the mountain. It looked like it was going to be a very dull day for photography. As I approached the end of the trail, however, the sky seemed to get a little brighter. I set up my camera equipment and waited only a few minutes before the sun shone through a hole in the clouds, directly onto Angel Glacier.

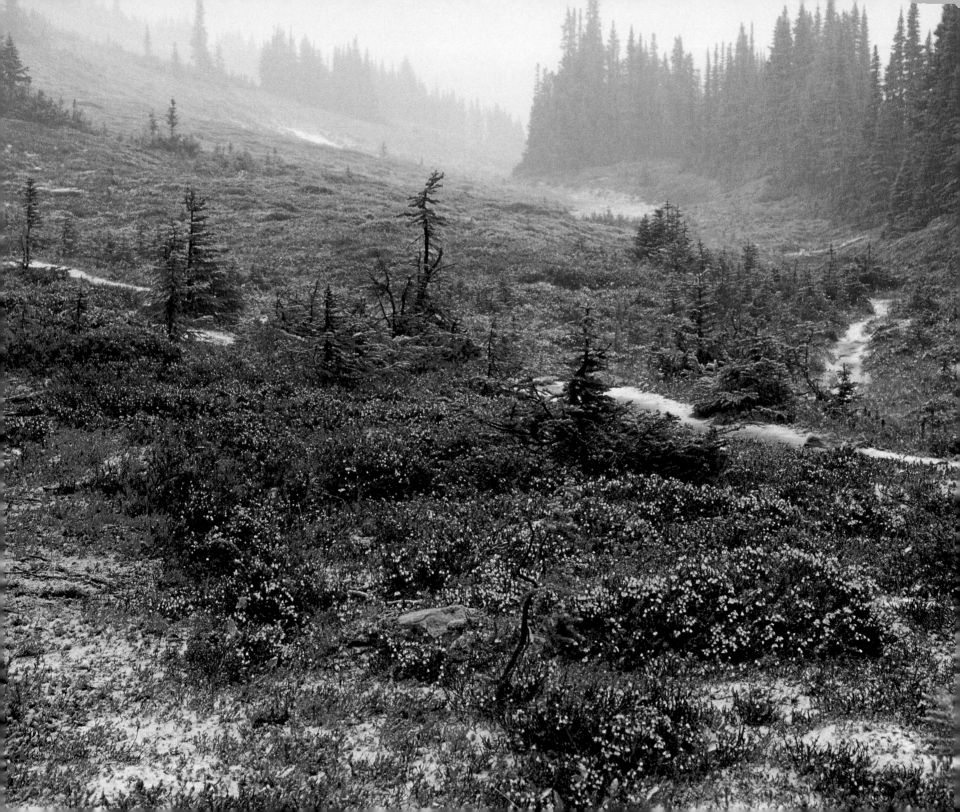

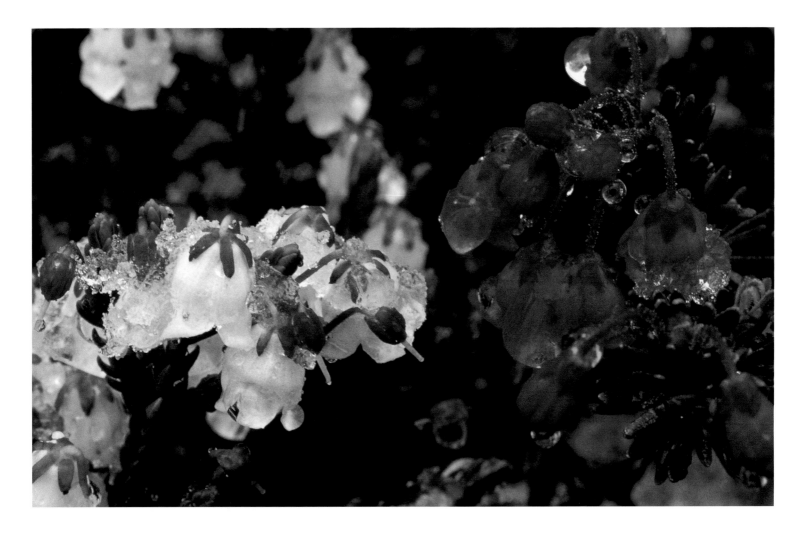

◀ After taking the photos of Angel Glacier I climbed up over the lateral moraine to the east and joined the 3.8 km. long Cavell Meadows Trail. By the time I reached the meadows an hour later it was raining, so I stood around under some trees, trying to find as much shelter as I could. I waited for about half an hour before giving up. About half way back down I stopped for a rest. When I looked back up the trail the sun was shining, so I turned around and headed back up to the top. By the time I reached the top for the second time it was snowing! I took these photos before heading back down again.

▲ Large areas of ground on either side of the trail through Cavell Meadows were covered with White and Pink Mountain Heather. After the rain and then the snow and freezing temperatures, they were all covered with ice. Mountain Heather is a low, creeping shrub only centimetres high, with flat, linear, evergreen leaves. It grows on slopes and meadows near and above the timber line.

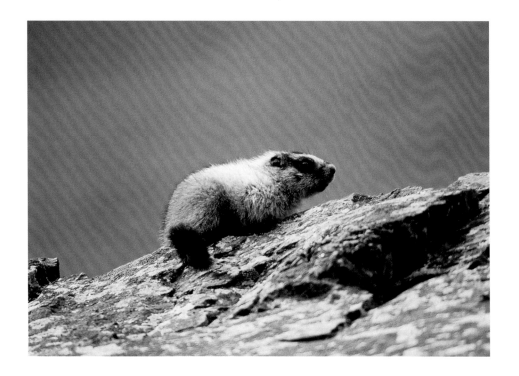

◀ *The Hoary Marmot, left, and the Yellow-bellied Marmot (a close relative), both live on subalpine slopes and rockslides of the Rocky Mountains. The Hoary Marmot is larger, inhabits higher elevations, and its range extends further north. Both animals live in extensive tunnel systems under the rocky terrain and hibernate for up to nine months of the year. Hoary Marmots are also known as "whistlers" because of the high, piercing whistle they use to communicate with each other.*

▶ *Although it looks like a rodent, the tiny Pika is a member of the rabbit family and is sometimes called a "rock rabbit" or "whistling hare". It is also a bit of a ventriloquist, which is something to keep in mind when trying to locate the animal by its call. Pikas live in the rubble of rockslides and boulder-fields at higher elevations, and spend their whole summer collecting succulent grasses and wildflowers to dry on sun-drenched rocks. They store the "hay" within the boulder-field for winter use. Pikas do not hibernate but stay active all winter.*

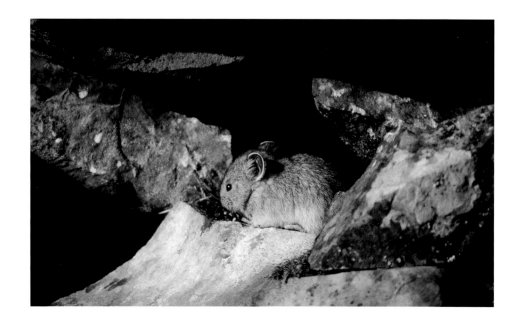

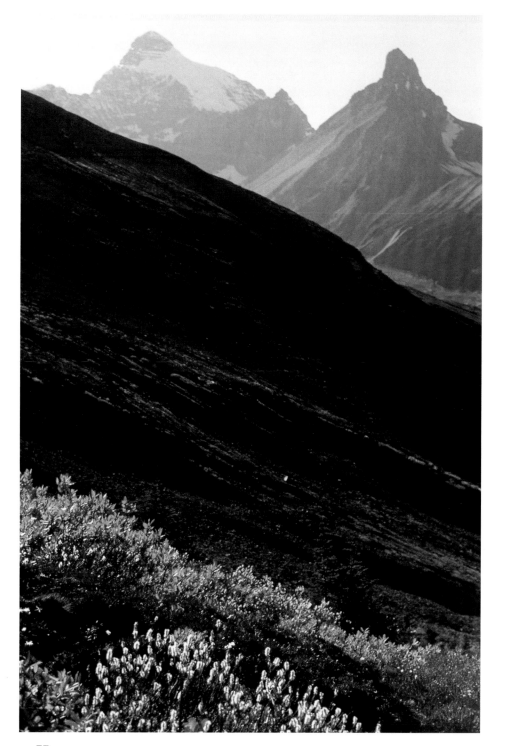

This large patch of autumn colour adds beauty to a steep mountain slope along the Parker Ridge Trail, near the Columbia Icefields. Fall comes early to the high alpine slopes and meadows. Parker Ridge, well above the tree line, is a fairly strenuous climb, but is well worth the effort. Whether you can afford only the time for a day hike or for a longer back-country trip, getting off the beaten path is much more rewarding than just getting out of the car at lookout stops. The mountain in the distance is Mt. Athabasca from the east, including Hilda Peak.

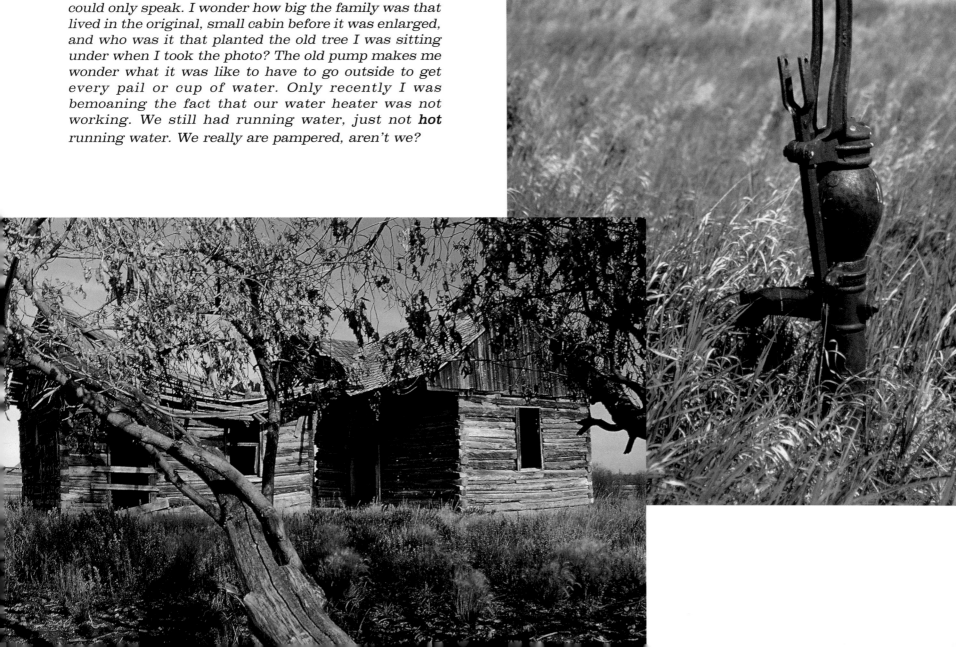

I found these very old, abandoned farm yards on two separate trips to the area north of Vegreville. Originally settled by peoples of Ukrainian heritage, there are numerous old log buildings in the area, many of them falling down but some still standing strong. I'm sure this old log house has many stories to tell if it could only speak. I wonder how big the family was that lived in the original, small cabin before it was enlarged, and who was it that planted the old tree I was sitting under when I took the photo? The old pump makes me wonder what it was like to have to go outside to get every pail or cup of water. Only recently I was bemoaning the fact that our water heater was not working. We still had running water, just not **hot** running water. We really are pampered, aren't we?

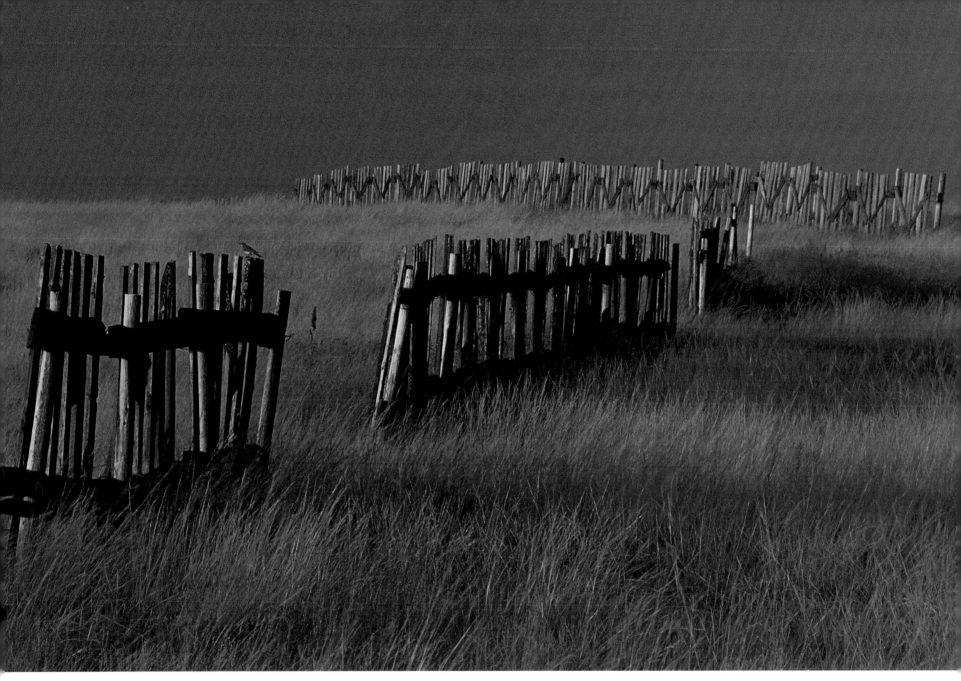

Sunset was fast approaching by the time I spotted this old snow fence just north of the Suffield Canadian Forces Base near Medicine Hat. I had to rush to get my camera gear set up, but I was able to take several photos from different angles before the sun dropped below the horizon. Even the Horned Lark co-operated by landing on the fence while I was making my photographs.

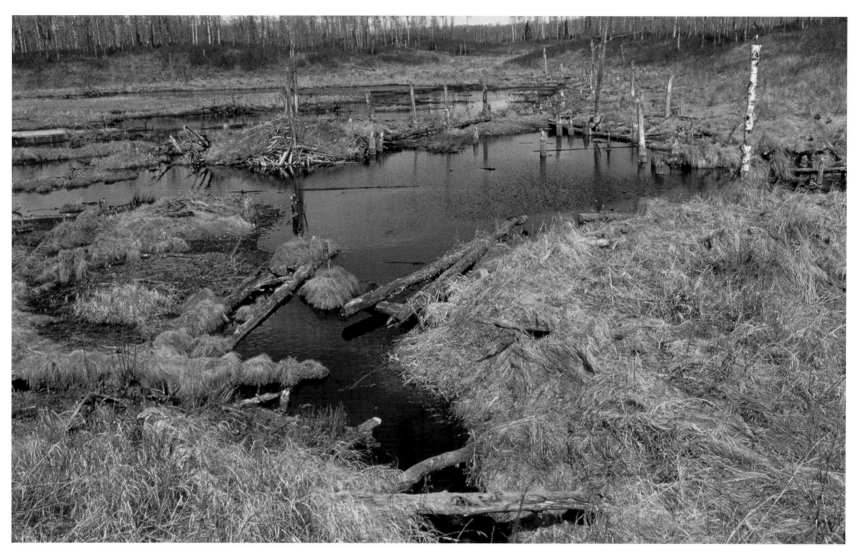

Canada has more area of muskeg than any other country in the world – over a million square kilometres. Muskeg occurs in depressions or poorly drained flatlands characterized by a wet environment and the formation of peat. The ground surface often consists of hummocks and hollows; with grasses, sedges, reeds and water mosses growing in the hollows, and woody shrubs growing on the hummocks. In spruce bogs the water is poor in minerals and low in oxygen, but is strongly acidic due to the actions of sphagnum mosses. Decomposition in these acidic conditions is very slow, which leads to a deep accumulation of peat deposits over time. In other parts of the world peat is used extensively as a fuel. Most muskeg is found in the boreal forest regions of the north, and can make travel and road or rail construction very difficult. As a result, many northern communities have land access to the south only during winter.

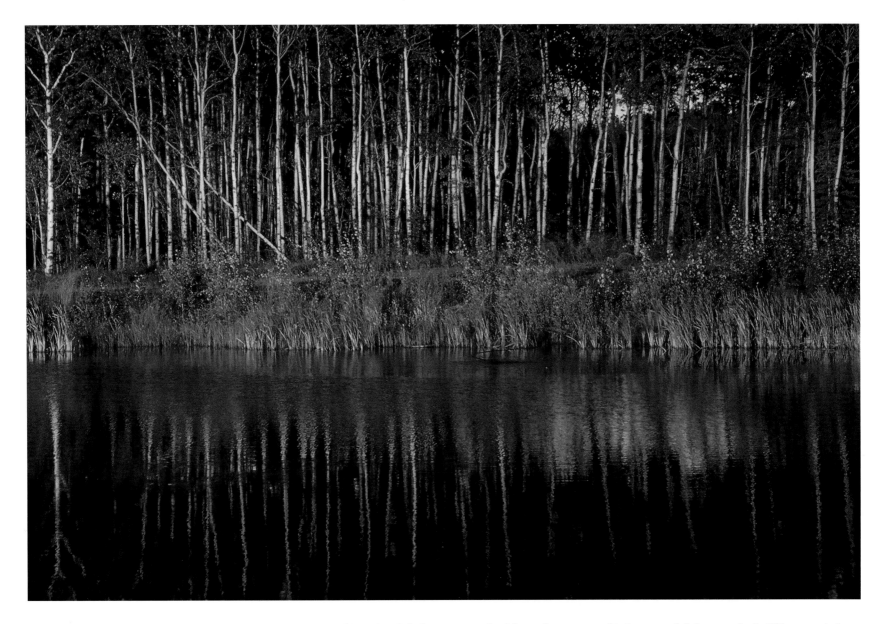

This is just a large dugout alongside the highway, probably a borrow pit from which needed fill was taken during construction of the road. I was on my way north, near Manning, when I caught a glimpse of the reflection out of the corner of my eye as I passed. I almost didn't bother turning around and going back, but I'm glad I did.

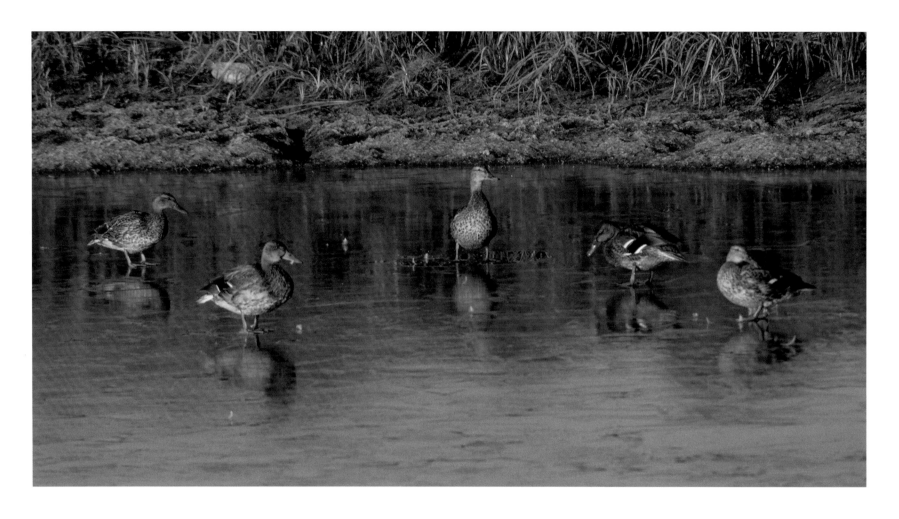

My wife and I were cruising around the back roads near Bragg Creek early one fall morning when she looked past me out the side window and asked, "What are those ducks doing?" I stopped the truck and looked through my long lens to see that they were "walking on water", or more correctly, they were walking on ice. I think the early frost had caught them off guard because they sure looked confused, and could hardly stand up on the slippery surface.

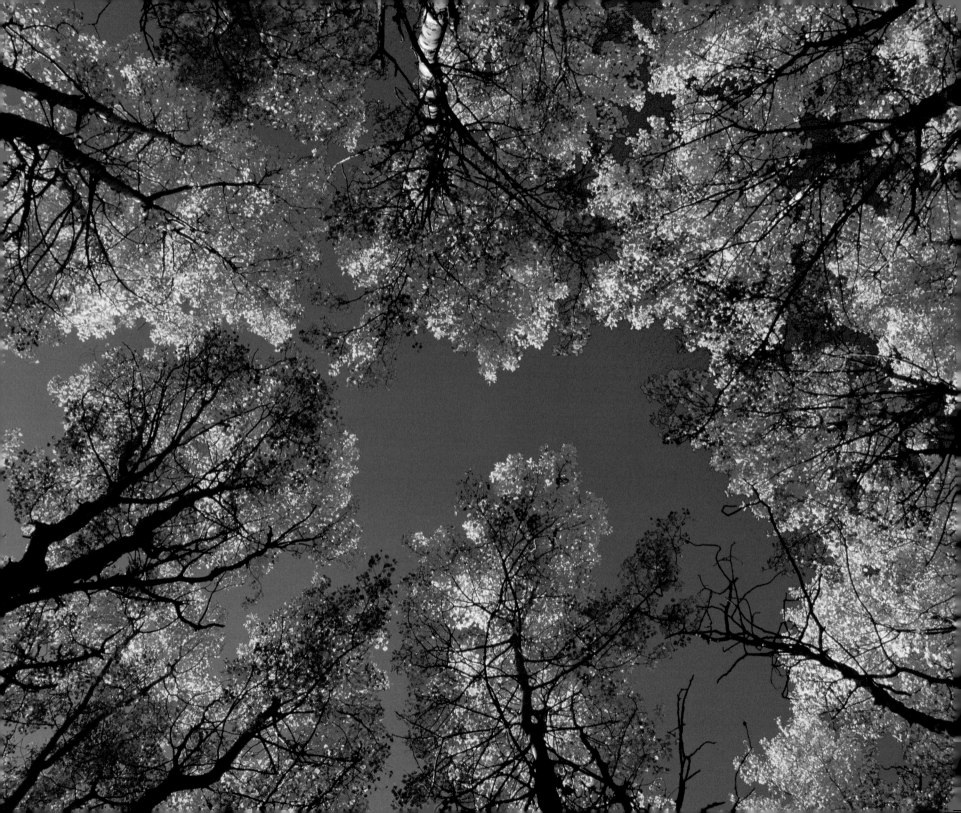

◄ *My brother-in-law has a photo similar to this. I had admired it and tried several times to take one like it, without much success. Previous images I had captured just didn't meet my expectations. This shot was taken, looking straight up to the bright blue afternoon sky, at a little place called Queen Elizabeth Provincial Park just west of Peace River. I stopped there for lunch one day, at the peak of the fall colours, and walked nearly every trail in the park in about an hour. Most aspens reproduce without seeds. Stands of genetically identical trees, called clones, grow as suckers from underground shoots off the parent tree, and can cover huge areas. All members of a "clone" will produce, and drop their leaves at the same time.*

► *Autumn colour shots can really be spectacular, providing the wind doesn't get to the newly turned leaves before the photographer does. This photo was taken on the same trip as the one on the opposite page, probably only a day later. I was traveling down Highway #40, the Big Horn Highway, and stopped outside of Grande Cache for a rest. Everything was peaceful, there was a single fisherman in a small boat on the lake, and the colours were absolutely stunning!*

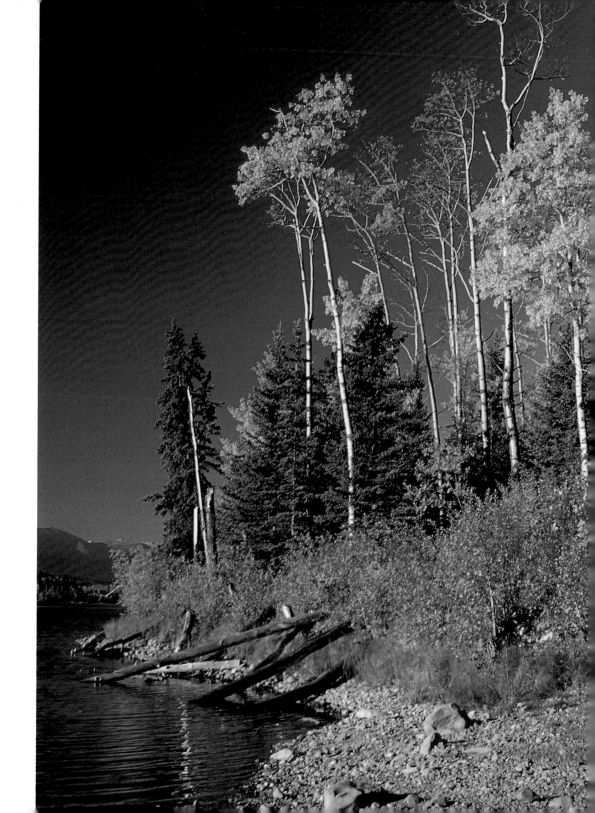

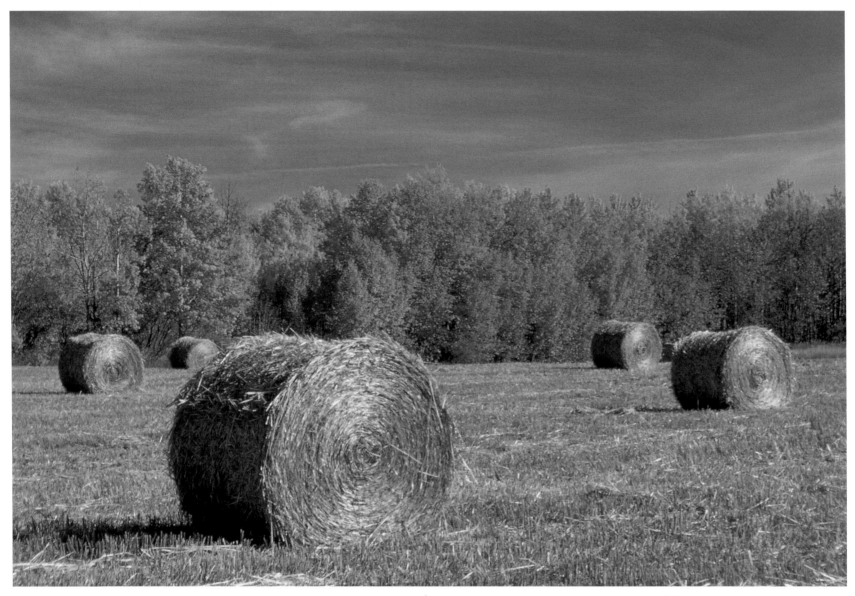

▲ *This image was captured just south of Peace River, on a beautiful fall morning. I had come from Winagami Lake Provincial Park where I had spent half the night photographing the northern lights. I had already shot a roll of film in the early morning fog before I found this huge field scattered with golden bales. I took several photos from different angles while the farmer continued to pick up the bales and haul them to a winter storage area.*

▶ *Because this scene so typifies the theme of this book, it didn't take me long to decide to use it on the cover. The light on the rolling foothills and farmland creates a great foreground for the mountains and blue sky in the distance. The photo was taken on one of my many trips along Highway #22 between Calgary and Pincher Creek – one of my favourite drives in all of Alberta. I don't know exactly what it is, but there is something special about that area of the province that appeals to me.*

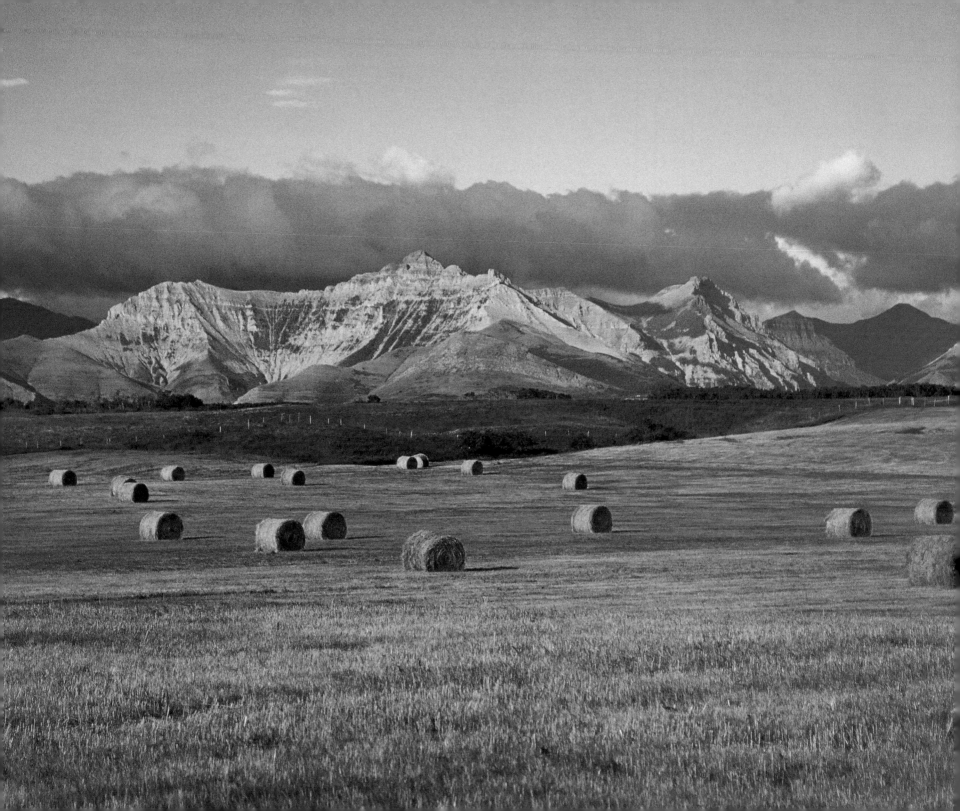

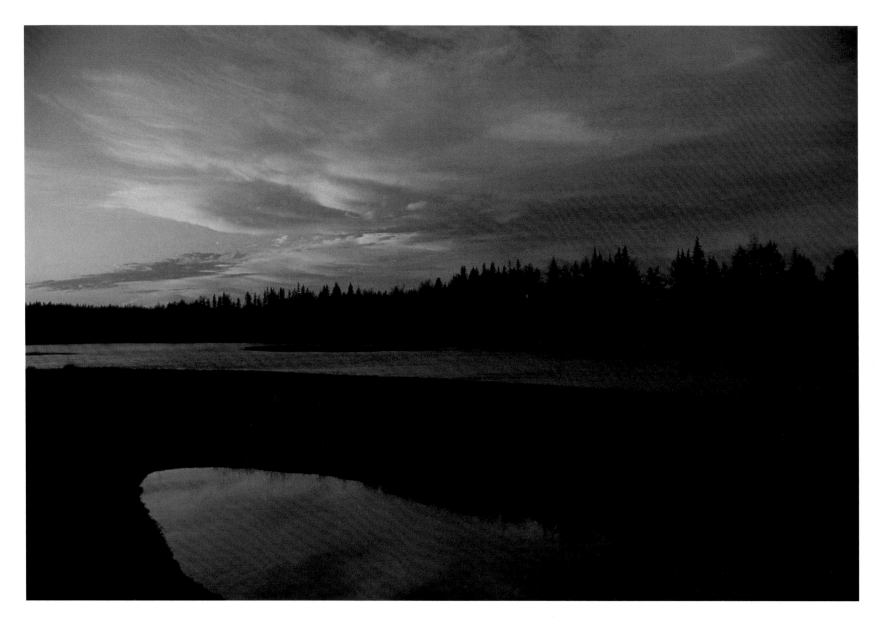

After spending the night in Rocky Mountain House, and hitting the road early, I didn't get very far before stopping to take my first photographs. This is another of those cases where the sky is much more interesting, at sunrise or sunset, if you turn around. In this case I was looking west over the North Saskatchewan River as the sun was rising behind me.

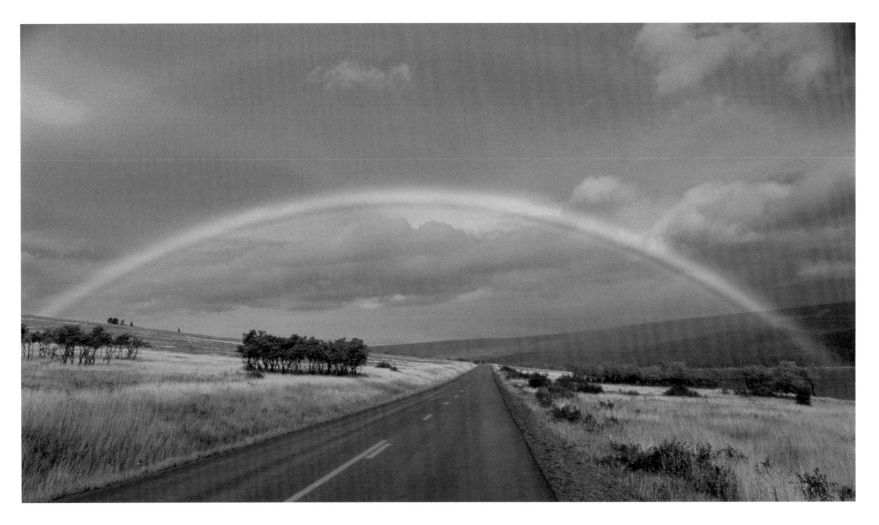

Like a lot of people, I can't resist the beauty of a rainbow. This one I couldn't miss as I was driving straight towards it. It's often impossible to get both ends of the rainbow into a photograph without a super wide lens (which I don't have). This time, however, the horizon was a little higher on one side, so the span of the rainbow was slightly less, enabling me to get it all into the composition.

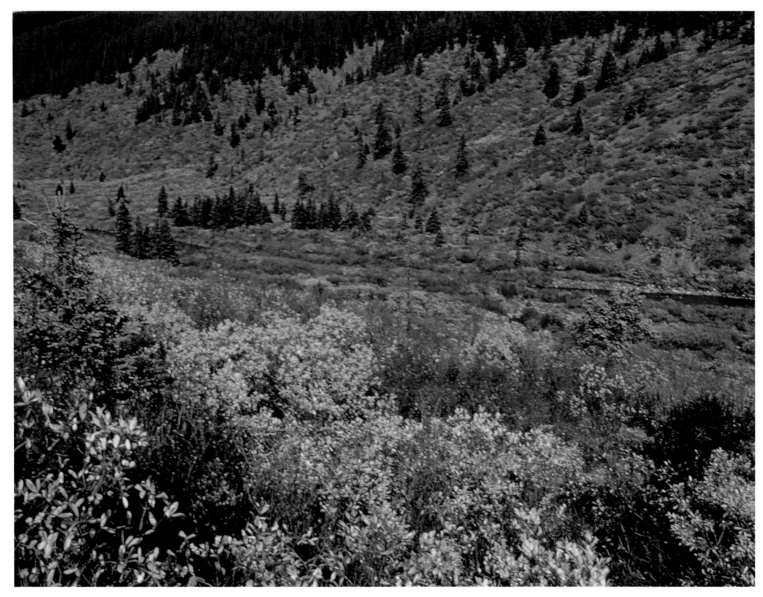

I have never seen such intense autumn colour, in shrubs and ground cover, as my wife and I saw on our holidays a couple of years ago, in the foothills south of Cadomin. In the early 1900's there were many coal-mining towns, collectively known as the "Coal Branch", between here and Edson. They supplied the Grand Trunk Pacific Railway locomotives with huge quantities of coal, but when the railways switched to diesel after the Second World War, most of the mines closed.

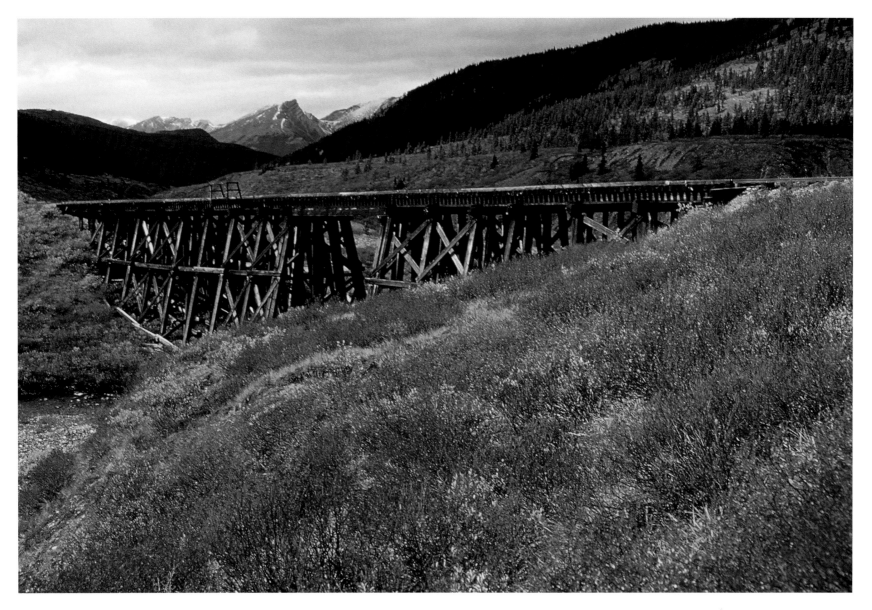

At about the same time there was a large town named Mountain Park about 20 km. south of Cadomin. There is nothing left there now except the cemetery, but much of the railway which once carried the people in and the coal out is still in place. Parts of the roadbed have been washed away and many of the wooden ties are rotten, but this large trestle is still standing. Although unsafe to walk on, it made a perfect prop for this photograph.

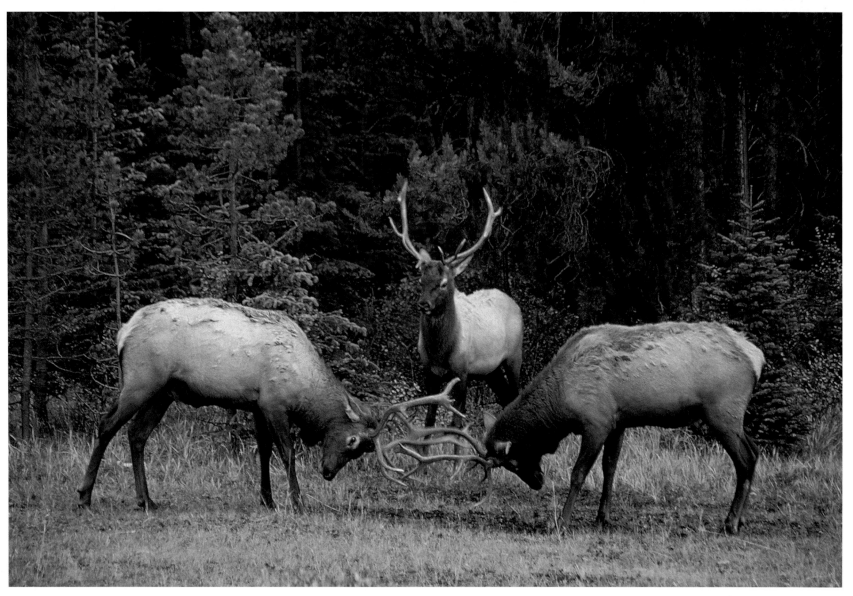

The sunlight was starting to fade as we were driving back to our campsite at Pocahontas from Maligne Lake, but I decided to make a short detour up the road to Jasper and back. I commented to my wife, "Maybe we'll find a couple of elk battling it out!" I wasn't really expecting it to happen as we had been searching for such a situation for several days, so we were extremely excited to come across these three young bulls taking turns at each other. We watched and photographed for an hour as two of them would square off with each other until one tired out and backed away. The third bull would then step in and take his place until one of **them** tired, and the one that had been resting would step back in to go another round. Elk are native to the Rockies but were exterminated from their southern range around the turn of the last century. They were reintroduced from Manitoba and Yellowstone National Park in the early 1900's.

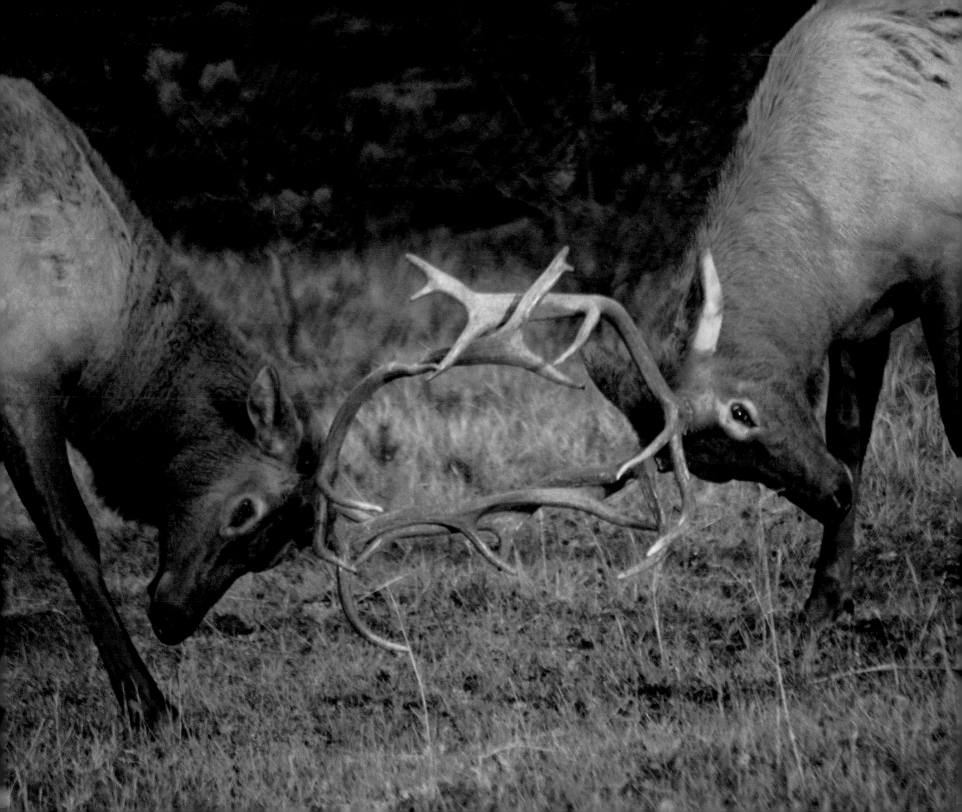

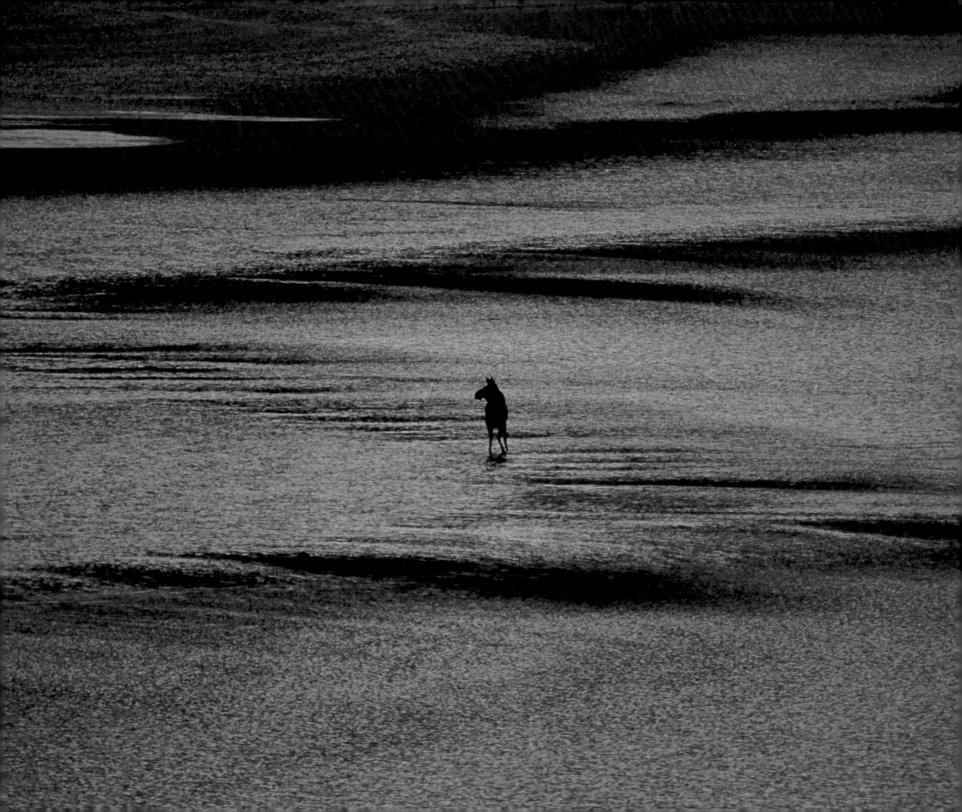

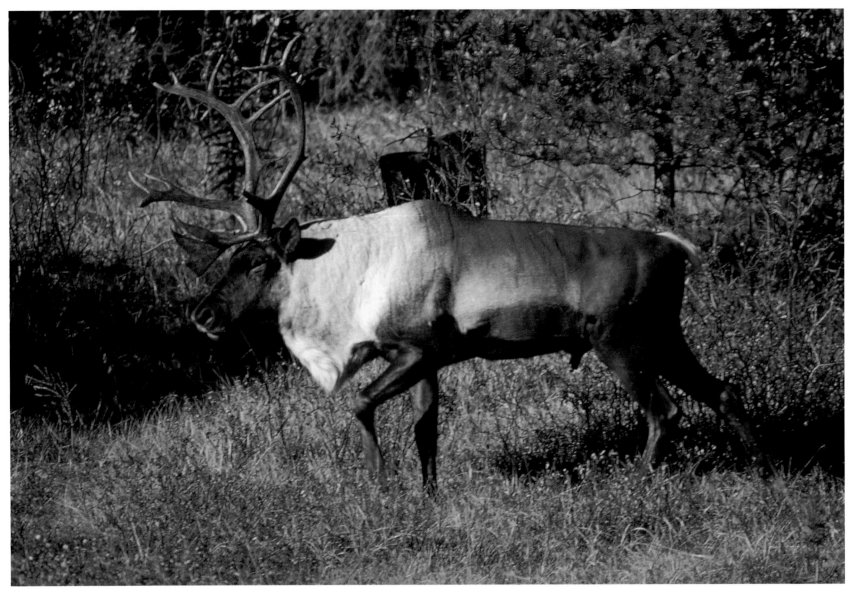

◄ It was almost dark as my wife and I were driving towards Jasper along the Maligne Lake Road and spotted this cow moose walking across Medicine Lake. Although it is large, the bottom of Medicine Lake is peppered with holes,or "sinks", that allow the water to drain out through underground waterways at the rate of 24,000 l/sec. Spring runoff fills the lake, but by late summer the outflow is greater than the inflow, and by fall the lake consists of only puddles and streams.

▲ The Caribou is the only member of the deer family in which both sexes grow antlers. Woodland Caribou inhabit northern forests and bogs of Alberta, and the slopes of the Rockies, where they are often referred to as "Mountain Caribou". Although it is estimated there are over 3000 Caribou in Alberta, roadside sightings are rare.

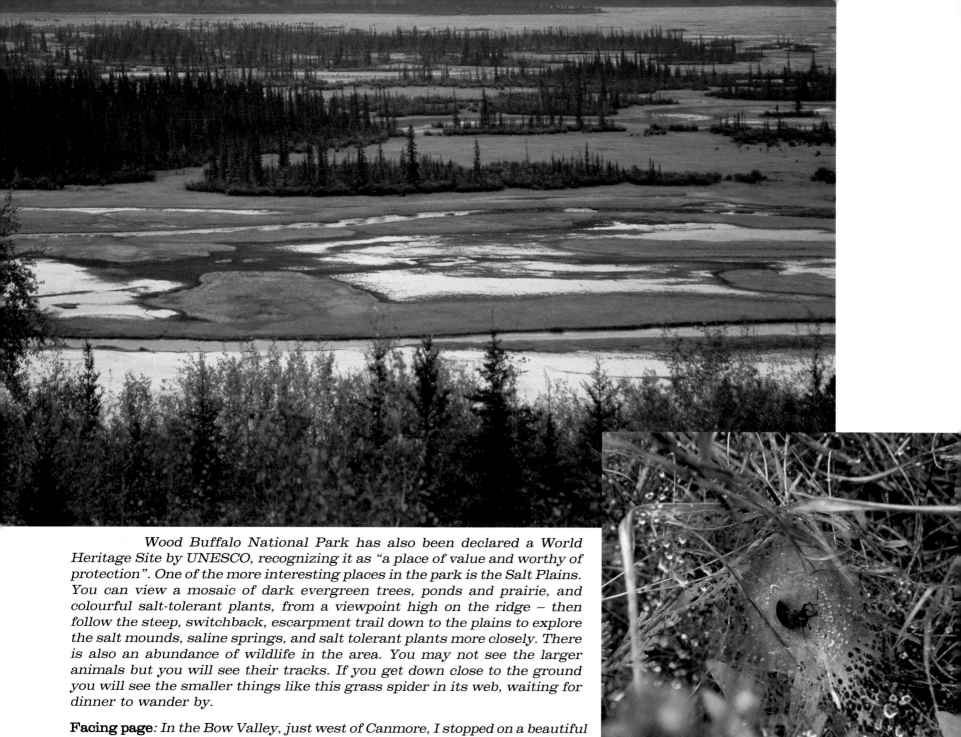

Wood Buffalo National Park has also been declared a World Heritage Site by UNESCO, recognizing it as "a place of value and worthy of protection". One of the more interesting places in the park is the Salt Plains. You can view a mosaic of dark evergreen trees, ponds and prairie, and colourful salt-tolerant plants, from a viewpoint high on the ridge – then follow the steep, switchback, escarpment trail down to the plains to explore the salt mounds, saline springs, and salt tolerant plants more closely. There is also an abundance of wildlife in the area. You may not see the larger animals but you will see their tracks. If you get down close to the ground you will see the smaller things like this grass spider in its web, waiting for dinner to wander by.

Facing page: *In the Bow Valley, just west of Canmore, I stopped on a beautiful autumn morning to admire the colours along the Bow River. Unfortunately there was way too much noisy traffic along the Trans-Canada Highway for a peaceful enjoyment of nature, so I didn't stay long.*

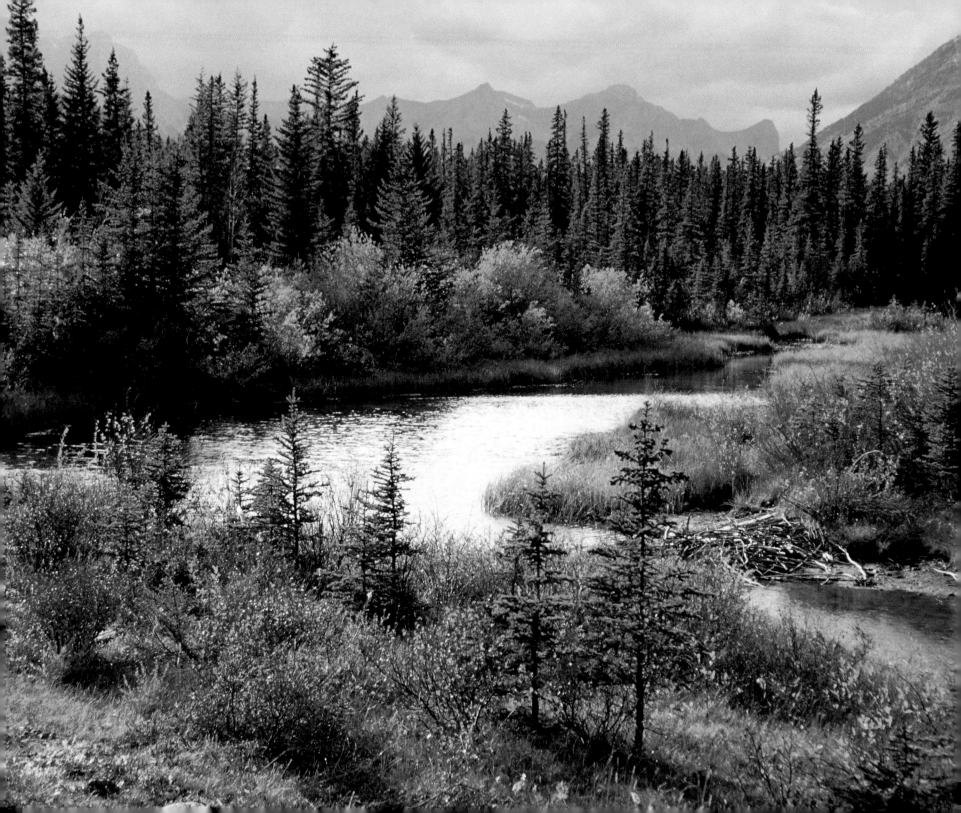

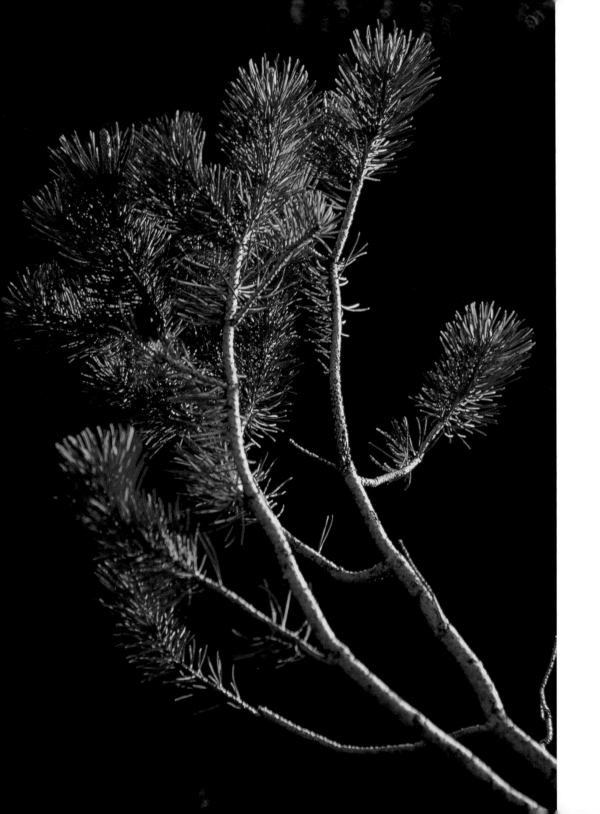

This beautiful pine bow is obviously not normal. It was probably affected by chinook winds that blow down the Bow Valley as many as 20 times in a typical winter. The Lodgepole Pine, in particular, is subject to a problem known as red-belt. It occurs when the warm chinook winds dry out the pine needles faster than the slowly moving sap can replenish them, but it doesn't usually kill the tree. The brilliant colours against the dark background attracted my attention, and that great contrast works to the photo's advantage.

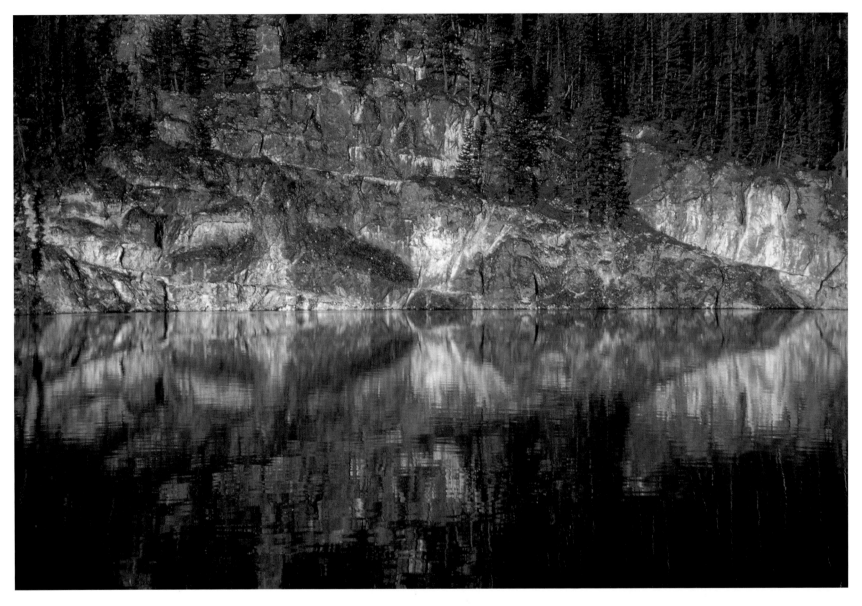

Brilliant sunrise light was streaming into the Bow Valley from the east as I made my way towards Banff along the Trans-Canada Highway. As I rounded the point of Mount McGillivray that juts into Lac des Arcs, I was almost blinded by this golden rock-face reflection. There was other traffic on the road and no place to pull over quickly, so I had to go several miles on the divided highway before I found a place to turn around and go back for this photo.

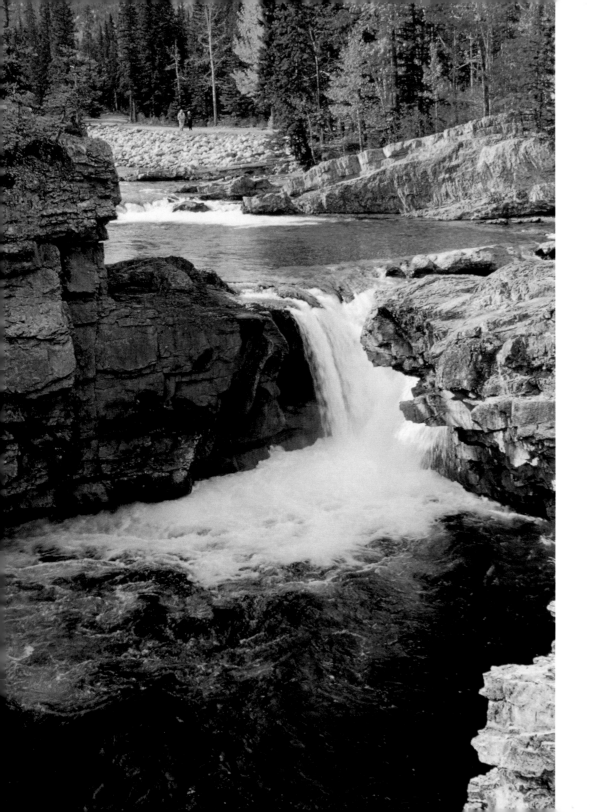

◄ *I had originally planned to use a photo of Elbow Falls that I had taken in the winter and found very pleasing. However, on my last trip to the area in September, I drove back up the Elbow Falls Road into Kananaskis Country and captured this image. I find it much brighter and more vibrant than the original.*

► *Mount Kidd, in Kananaskis Country, just north of The Fortress ski area, is one of the most striking and most distinctive mountains in the Rockies. It is also easily viewed from the Kananaskis Highway, especially from the south, where you drive directly towards it for several kilometres.*

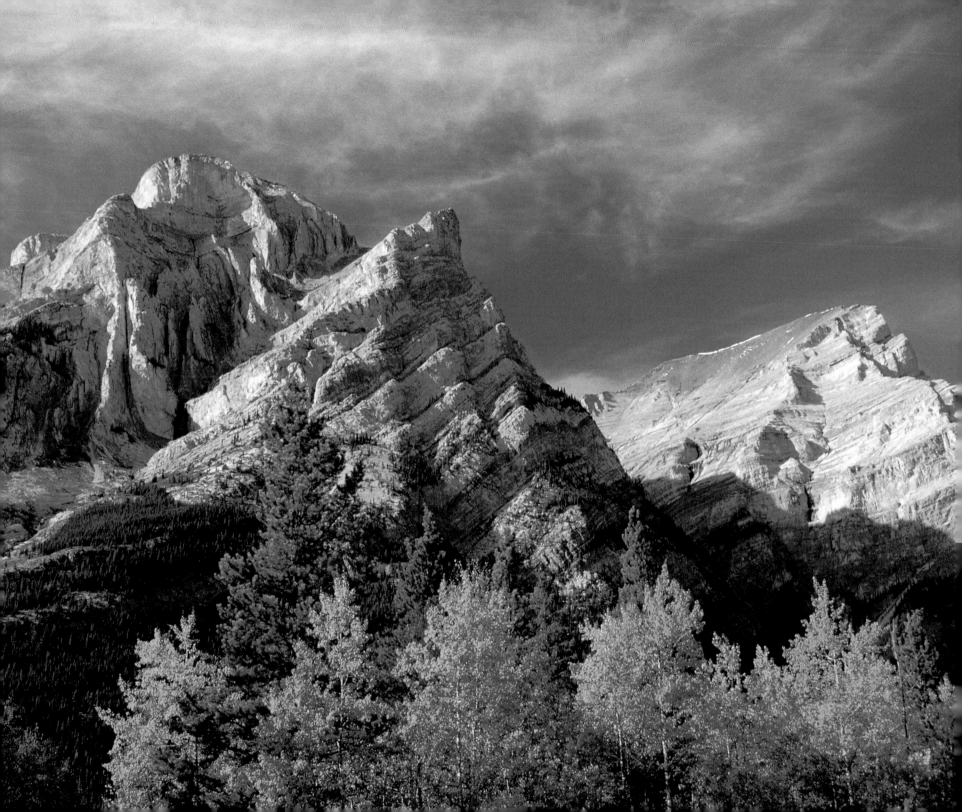

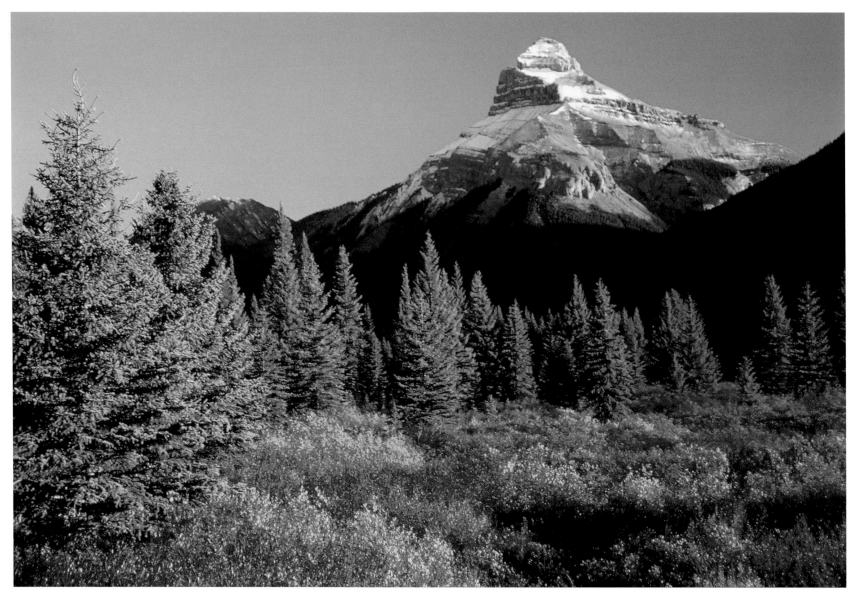

▲ One of the most identifiable mountains along the Bow Valley Parkway is Pilot Mountain. The Parkway, joining Banff and Lake Louise along the north side of the Bow River, is a much slower and quieter road than the Trans-Canada Highway. It was completed in 1920 and provided the first road access to Lake Louise. Motorists wishing to see more than quick glimpses of the mountains from a speeding vehicle would be advised to take this route.

▶ Here on Parker Ridge the temperature is even lower than other alpine areas, by as much as 10° C, due to the chilling influence of the nearby Columbia Icefields. Alpine shrubs and stunted clumps of fir and Engelmann spruce, known as krummholz, or "crooked wood", are preparing for winter. More than 6 m. of snow falls here annually, and though stunted, these trees are probably hundreds of years old. The mountain in the near distance is Mt. Athabasca with its outlier, Hilda Peak.

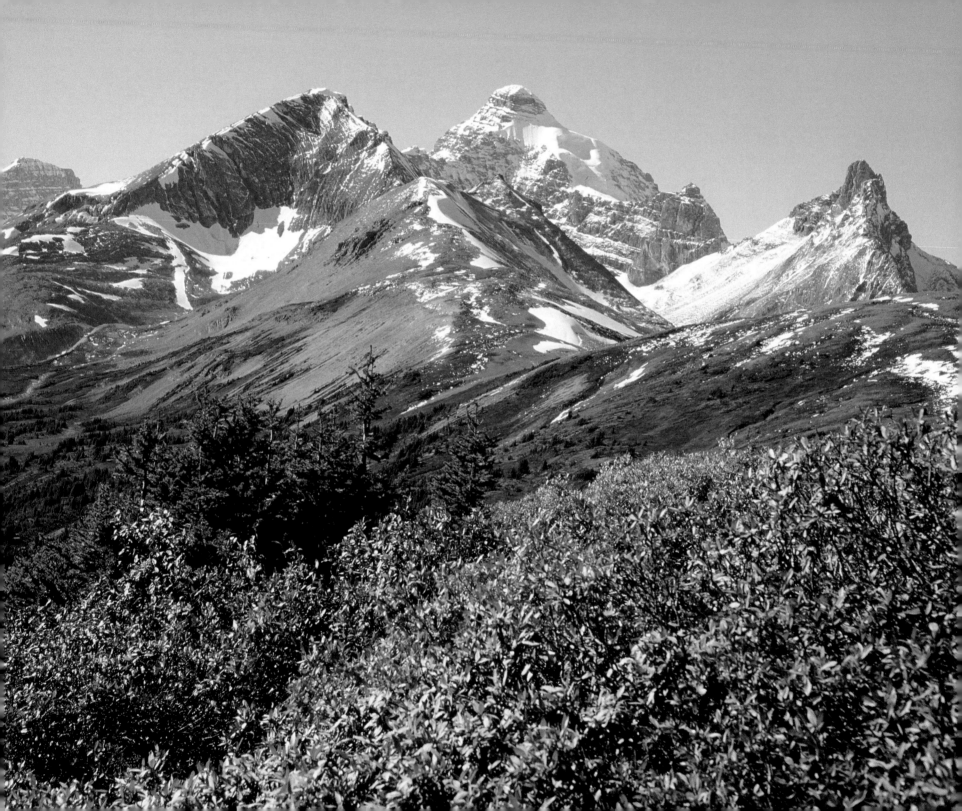

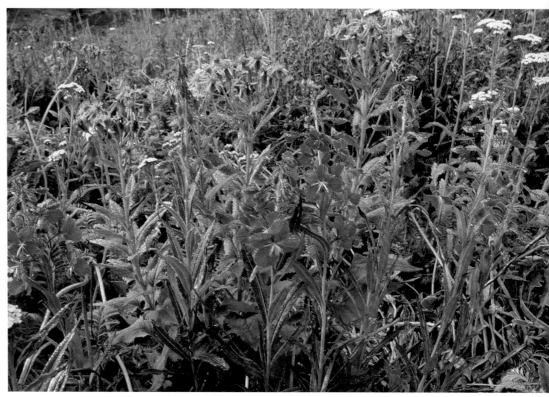

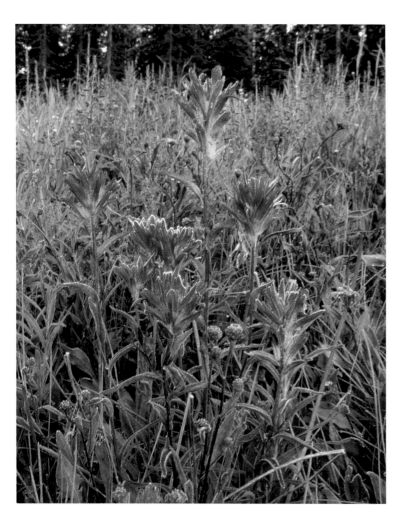

These frosty Indian Paintbrushes, along with the Fireweed, Yarrow and Ragwort in the above photo, are just warming up after a cold night at Moraine Lake in Banff National Park. Frost can come any time in the mountains – it was only late summer. I had been at Lake Louise for the sunrise, but when that didn't seem to be developing in any special way, I jumped in the truck and headed up to Moraine Lake and took these photos.

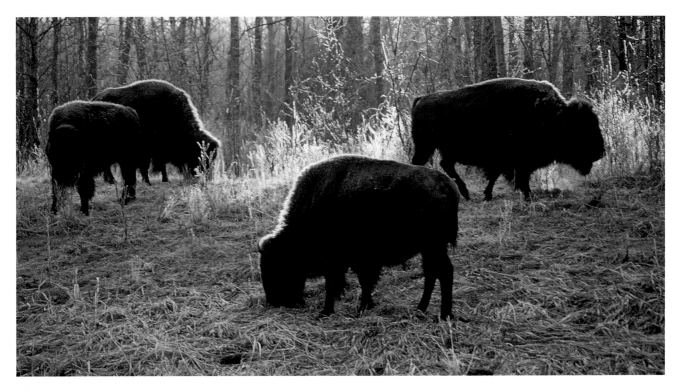

I photographed these *Plains Bison* in Elk Island National Park in the late fall, on a very frosty morning. I was up early again, because that's the best time to get wildlife to "pose", and took the backlit photo as the sun was coming up through the trees. I made the image of the large bull later on in the morning with the sun full on him but the frost from the night before not yet melted from his body. There are herds of both Plains and Wood Bison at Elk Island, but they are kept separate as they are genetically different from each other. The Plains Bison are kept north of the highway and the Wood Bison are kept south of it. The best way to tell the two apart is by the hump, which is over the front legs on the Plains Bison but further forward on the Wood Bison; and by the mane and beard, which are longer and thicker on the Plains Bison.

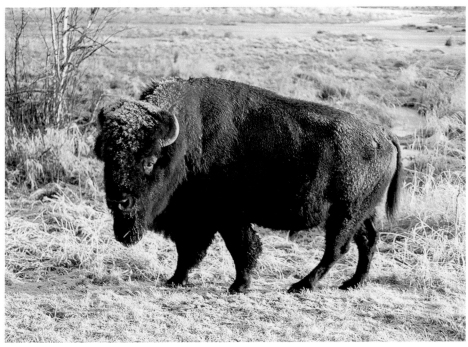

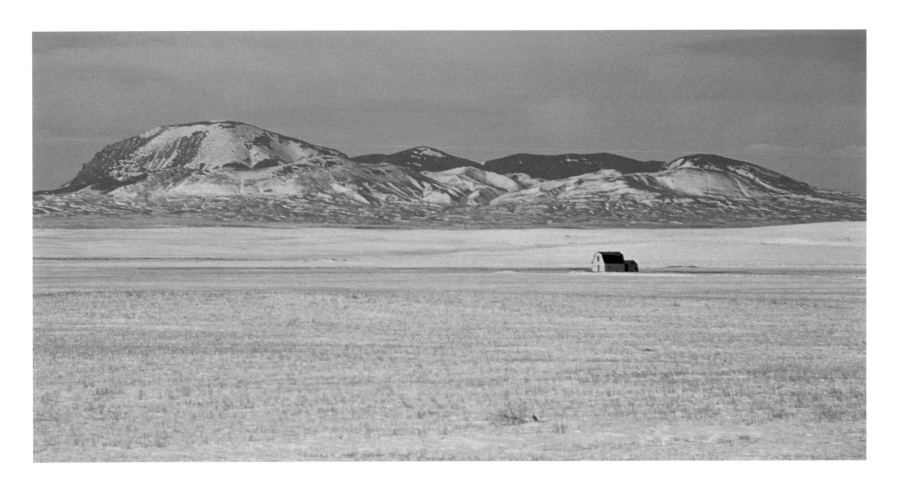

◀ *This unique photograph, featuring a light snow cover over a stubble field, was taken in east-central Alberta, near Oyen. I was making one of my many trips around the province, taking photographs, when the contrasting blue and yellow caught my eye. Simple – but interesting!*

▲ *The Sweetgrass Hills in the distance are actually in Montana, U.S.A., about 30 km. south of where I was standing when I took this photo. The hills tower above the surrounding prairie, at 2128 m., and were used by the Blackfoot as vantage points from which to look for buffalo herds. They were formed about 48 million years ago when magma forced its way up from inside the earth and cooled as a huge rock dome just below the surface. Erosion has done the rest.*

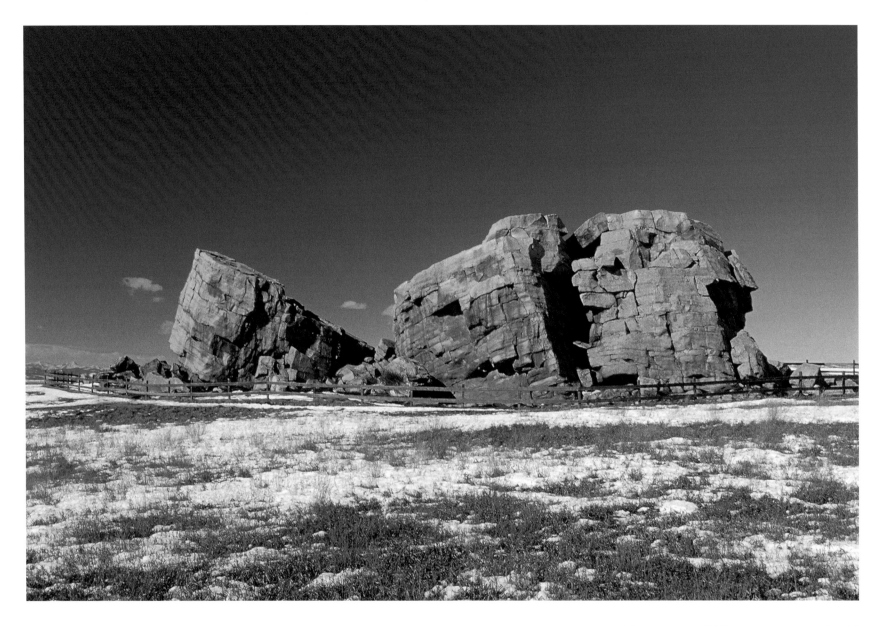

At one time this was a single rock, the largest of thousands spread along 600 km. of foothills more than 10,000 years ago. It is thought that a rock slide onto a glacier was spread along the line of the glacier's journey as it gradually melted. This particular boulder, near Okotoks, was 40 m. by 18 m. by 9 m. and estimated to weigh over 16,000 tonnes.

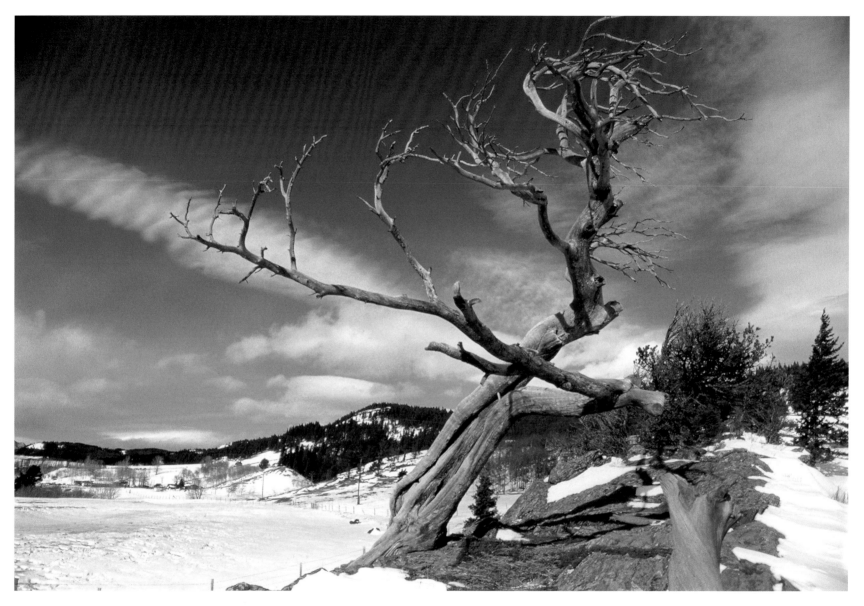

This is the famous Crowsnest Tree, somewhat the worse for wear. The constant winds that blow through the Crowsnest Pass can exceed 150 km/hr. Many of the trees continually exposed to this wind acquire a very rugged, gnarled and weather-beaten look. This one was photographed so often that when it died several years ago, someone figured it needed to be preserved, and bolted it back together.

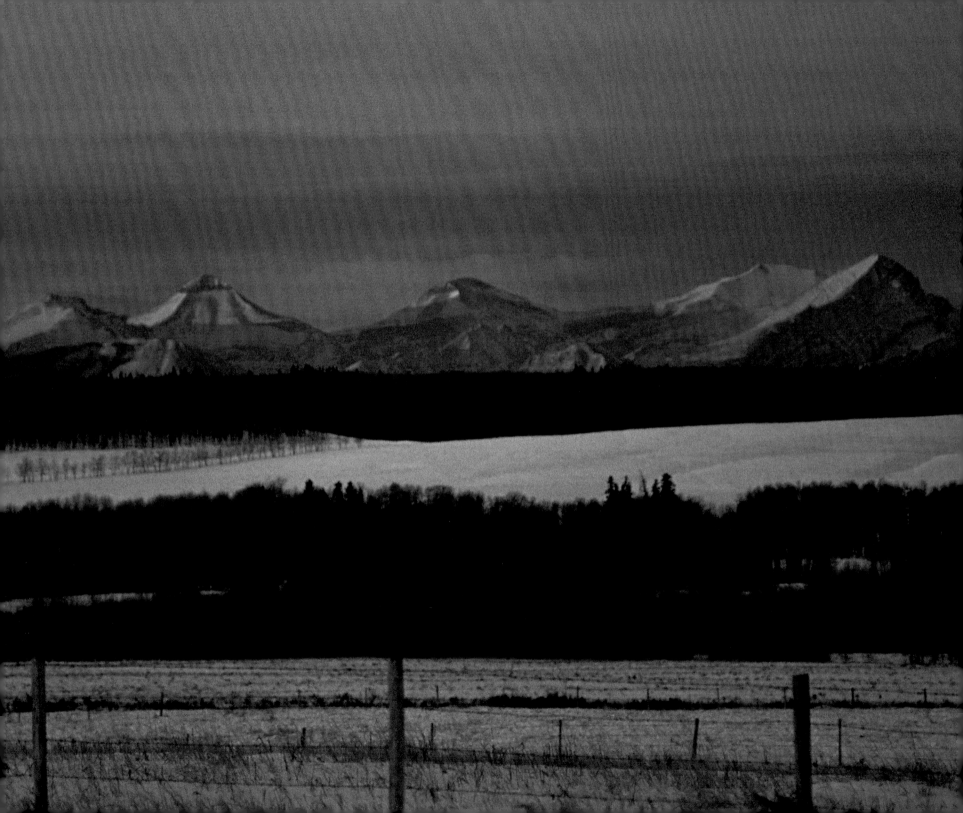

◄ *I captured this image from just off Highway #22, west of Calgary, on a very calm but cool winter morning. I took a series of photos from this spot on at least three separate occasions because the panoramic view of the mountains is three times as wide as shown here, and the mountains literally light up with the sunrise. Originally I had planned to use one of these photos for the cover of the book, but decided they were a bit too dark for that.*

▶ *This photo of stark contrasts, almost black and white, was taken on a very dull, overcast morning along the Akamina Parkway in Waterton Lakes National Park. Not the type of weather I would choose, to be photographing landscapes, but it sure conveys the feeling of a cold, bleak, winter day.*

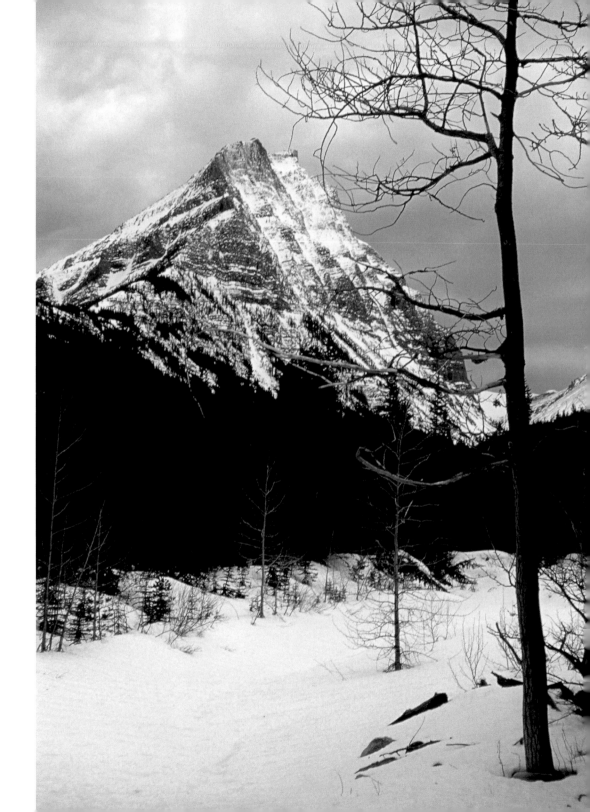

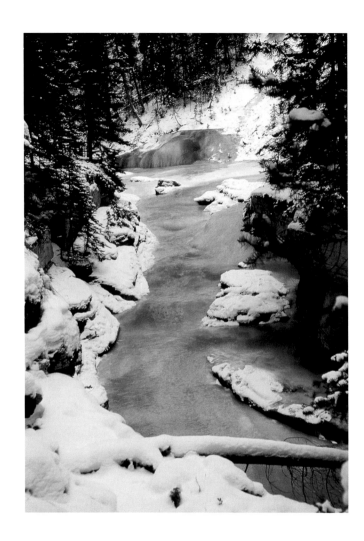

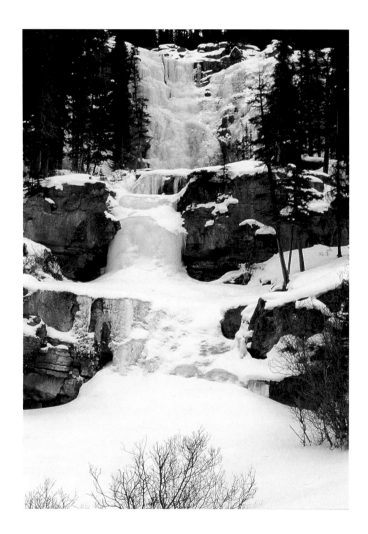

The mountains, especially water and waterfalls, are not nearly so alive and cheerful in midwinter as they are in spring and summer. You have seen these two sites before in this book, but in a different season. (Refer to pages 62 and 63.) Ice climbing is becoming a very popular winter sport in the parks. Some of the busiest sites are Johnston Canyon, The Weeping Wall, and other parts of Maligne Canyon.

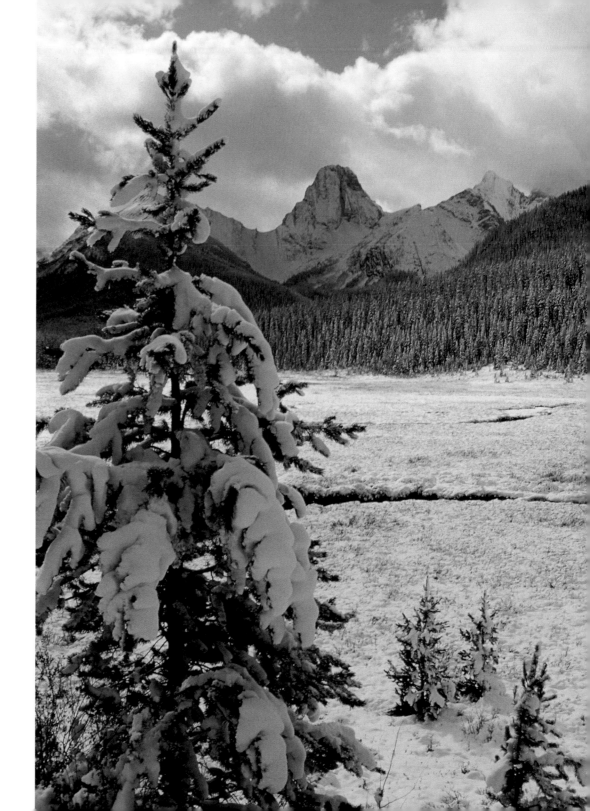

Much of Kananaskis Country was once part of Banff National Park, but was excluded in 1930 to allow for the construction of a hydro-electric project along the Spray River. The drive from Canmore to Peter Lougheed Provincial Park, along the Smith-Dorien/Spray Road, passes by the Spray Lakes Reservoir. Just past the reservoir is Smuts Creek, where I took this photo, looking south towards Mount Birdwood. Unlike the National Parks, Kananaskis Country is a "multi-use" area. That means the area incorporates provincial parks, natural areas, forestry reserves, grazing lands, mining and petroleum leases, as well as resort and recreational developments; which includes permitting the use of motorized vehicles.

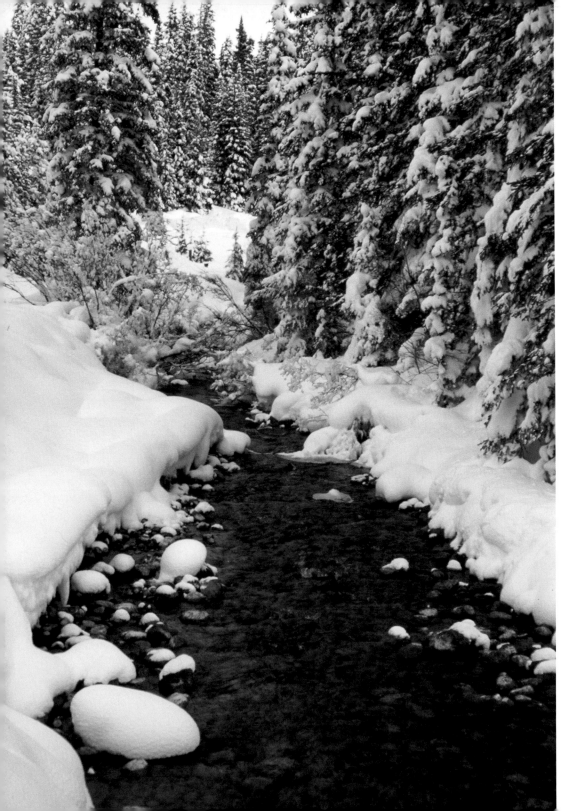

◄ *Lake Louise is 2.4 km. long, 0.5 km. wide, and 90 m. deep. The only outlet is Louise Creek, which tumbles down the valley to join the Bow River at the Lake Louise townsite. Although deep blue in the winter and spring, the water from the lake becomes a bright blue-green in the summer, as all glacial lakes do, because of the fine particles of glacial sediment called "rock flour". There is no significant mineral content in the water.*

▶ *The average annual snowfall at Lake Louise is over 4 m., which adds greatly to the beauty of this fairy-tale winter scene. The lake is frozen over from early November until early June. Even in summer it only warms up to about 9° C. The elevation of Lake Louise is 1731 m. – almost exactly half the way to the top of Mt. Victoria from sea level. On the right side of the photograph are The Beehive and Mount Whyte.*

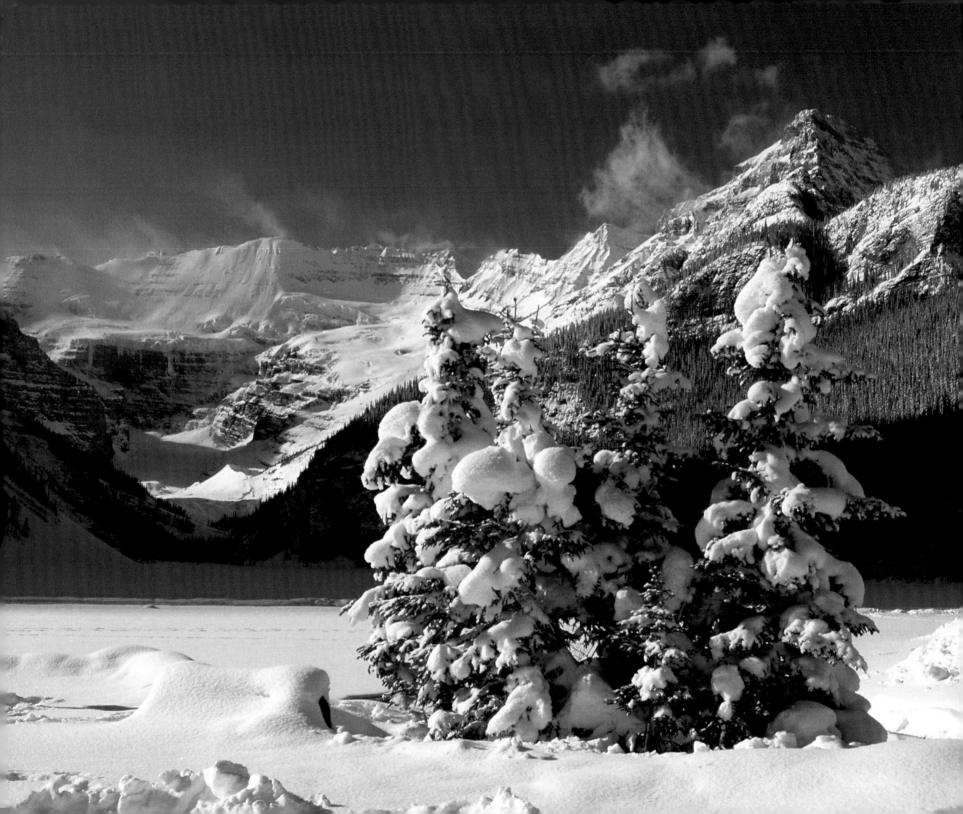

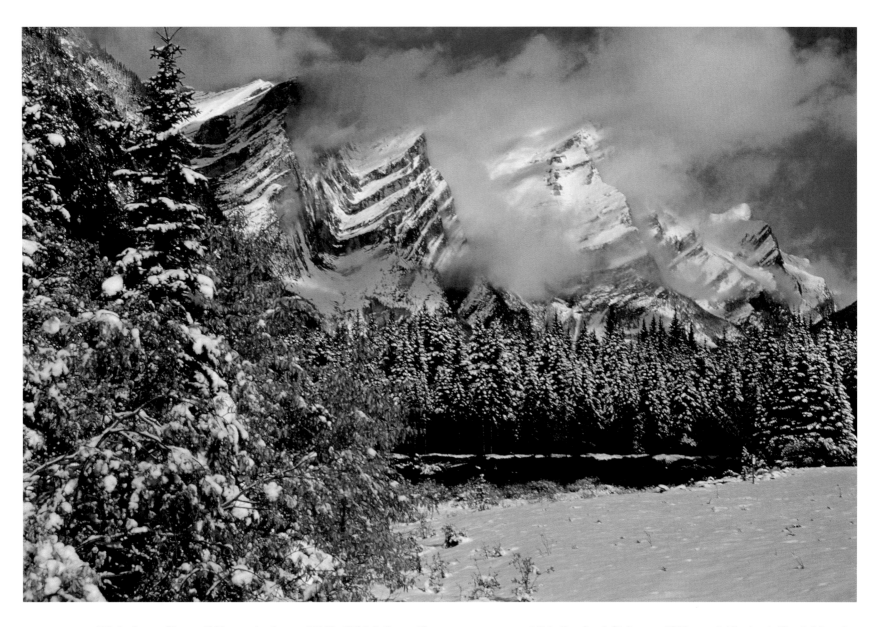

This is quite a different view of Mt. Kidd than the one on page 101. In fact it is so different that at first I had a difficult time identifying it. I had taken the photo after a late fall snowstorm but wasn't sure exactly where. The snow and fog had changed the look of the peak, but the distinctive fold helped me to identify it once I determined where I had been.

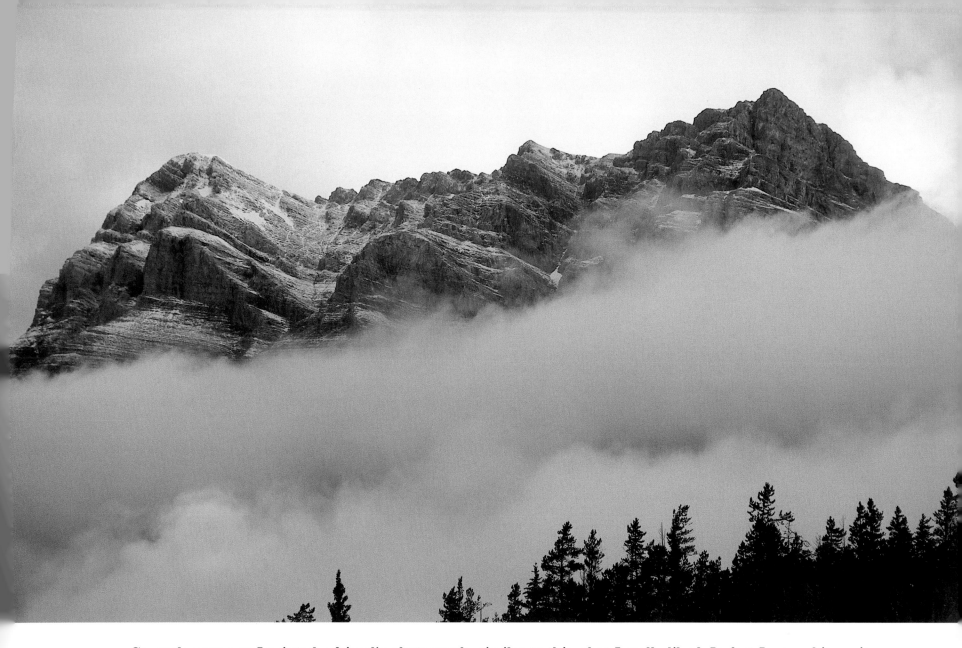

Several years ago I printed a friend's photograph, similar to this, that I really liked. In fact I was a bit envious. His was a photo that he had taken in the high arctic of a mountain peak just poking through the clouds. There was less mountain showing in his image and more cloud, but I like this photo very much as well. This is part of Mount Wilson near Saskatchewan Crossing. Fording the North Saskatchewan River at high water was one of the greatest hazards of early travel in this part of the Rockies. Many supplies were lost and many an outfitter or client went for an involuntary swim.

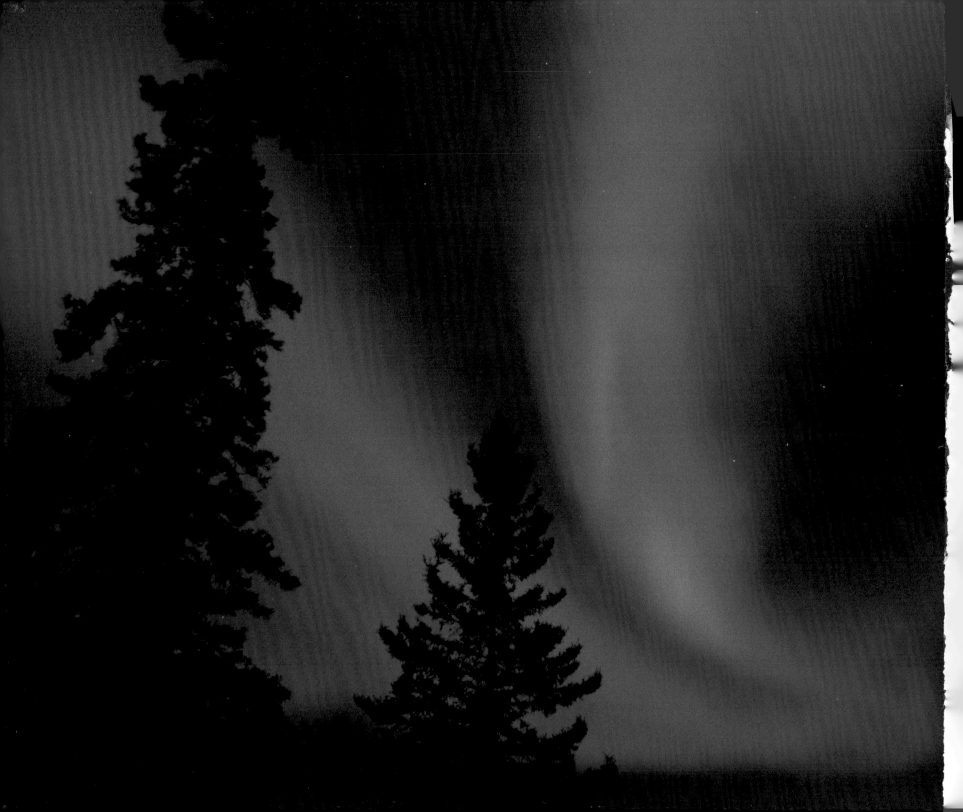

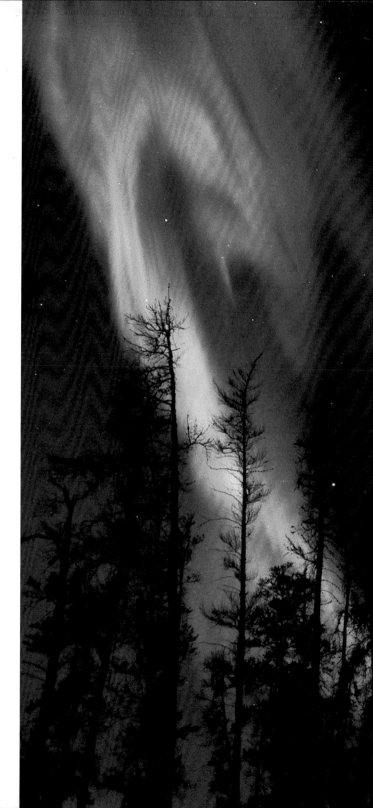

The Aurora Borealis – the Northern Lights – are a fairly common occurrence in the northern parts of the province, especially on cold winter nights. These photos were taken in Wood Buffalo National Park, but only in late August. Sometimes the lights "dance" around the sky very quickly, and even with high speed film it's hard to get a sharp image. Sometimes though, they move rather slowly, and a very sharp image is possible, with real colour and pattern definition. In spite of what most people think they see, Northern Lights most often appear green, but **can** be almost any colour of the rainbow.